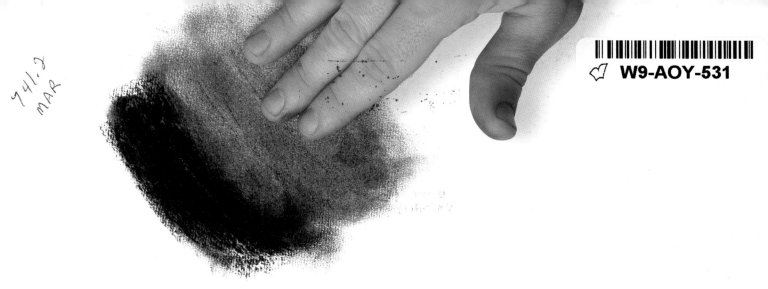

W9-AOY-531

DRAWING

FOR THE BEGINNING ARTIST

Practical techniques for mastering light and shadow in graphite and charcoal

by Gabriel Martín

Tools & Materials, 4

Con

Techniques, 18

tents

Subjects, 66

Tools & Materials

The ideal way to effectively shade a drawing is by using dry techniques with graphite, charcoal, chalk, sanguine, etc. These materials allow you to create broad, opaque shadows, as well as a large variety of different tones, gradations, and shades. All of these materials, along with ink washes, are the main resources you will use when working with the various shading techniques in this book. Shading with light and shadow creates a very dramatic effect of illumination. The more intense and bold the contrast is between the light and dark values, the greater the sense of volume will be. In the following pages, we will show you the most commonly used drawing tools for shading; by extension, these are also the most common tools for drawing light and shadow.

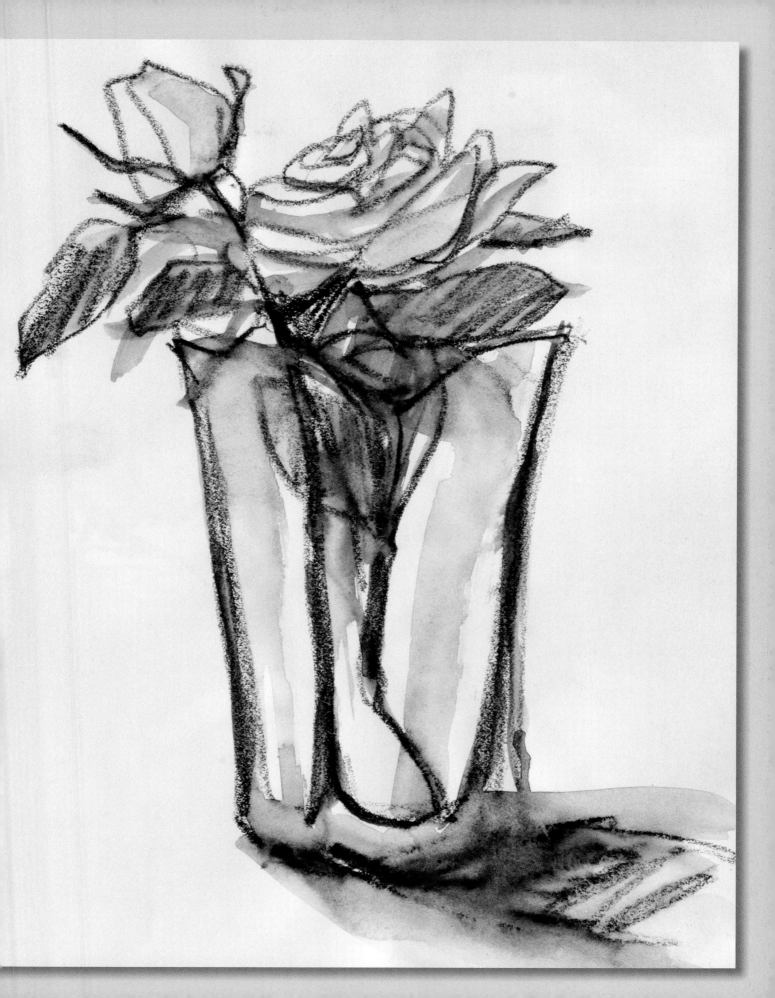

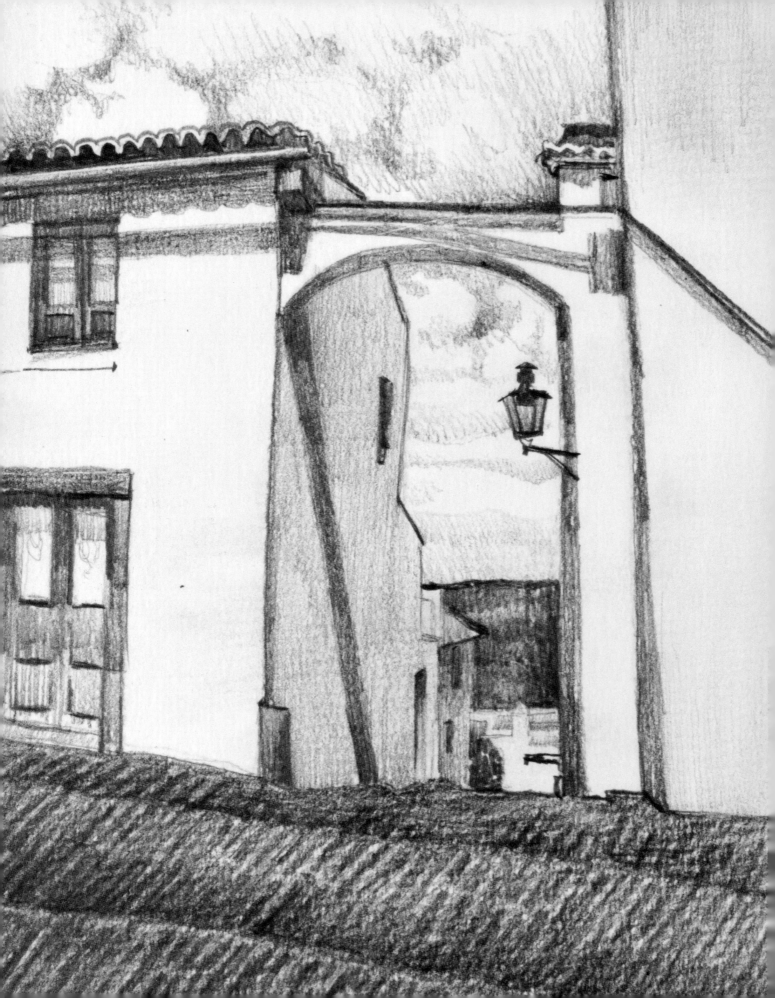

The thickest sticks are those with hexagonal, cylindrical, rectangular, and square shapes.

The standards of hardness for woodless graphite pencils are the same as they are for conventional pencils. If you angle the tip of the pencil, it will allow you to quickly shade broad areas of the paper.

Graphite Pencils

Graphite is a mineral, the color of bright gray lead, that is blended with powdered clay and a binding agent. It is used to manufacture pencils that create fine strokes, in tones ranging from very light to very bold shades of gray. However, none are completely black.

SHADING WITH GRAPHITE PENCILS

When shading with graphite pencils, it is preferable to use a variety of different hardnesses in order to vary the intensity of the strokes and shading. The hardness of the lead in a pencil is indicated with numbers and letters on the outside of the wood casing: an H indicates hard lead, which will produce a very soft

shade of gray; B indicates soft lead. The best pencils for shading are 4B through 9B. They will provide you with a better proportion of clay and more pigment; as a result, they will allow you to produce deeper, almost entirely black tones of shading.

WOODLESS GRAPHITE PENCILS AND STICKS

Woodless graphite pencils are formed in the cylindrical shape of a pencil. They can be used the same as a conventional pencil, although they are thicker, ranging from 0.8 to 1.5 cm. The standards for the hardness of the lead are the same as those with conventional pencils; however, the compact nature of the graphite sticks will allow you

to draw thicker strokes and create broader shading. In addition to cylindrical woodless graphite pencils, there are also rectangular, square, or hexagonal bonded graphite sticks.

WATERCOLOR GRAPHITE

It is increasingly common to find watercolor varieties of all types of woodless graphite pencils and sticks. Most brands currently offer a watercolor version of their graphite products, in different forms and assortments.

Graphite pencils are arranged according to progressive degrees of hardness. It is a good idea to have a broad selection to be able to shade with various values.

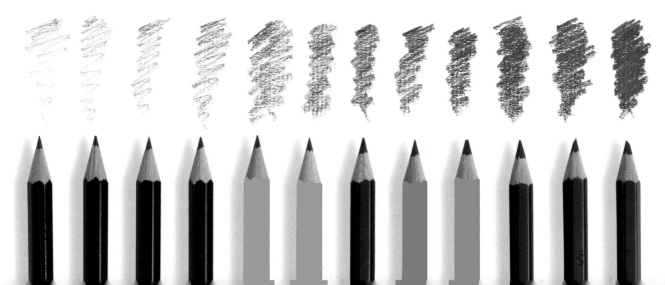

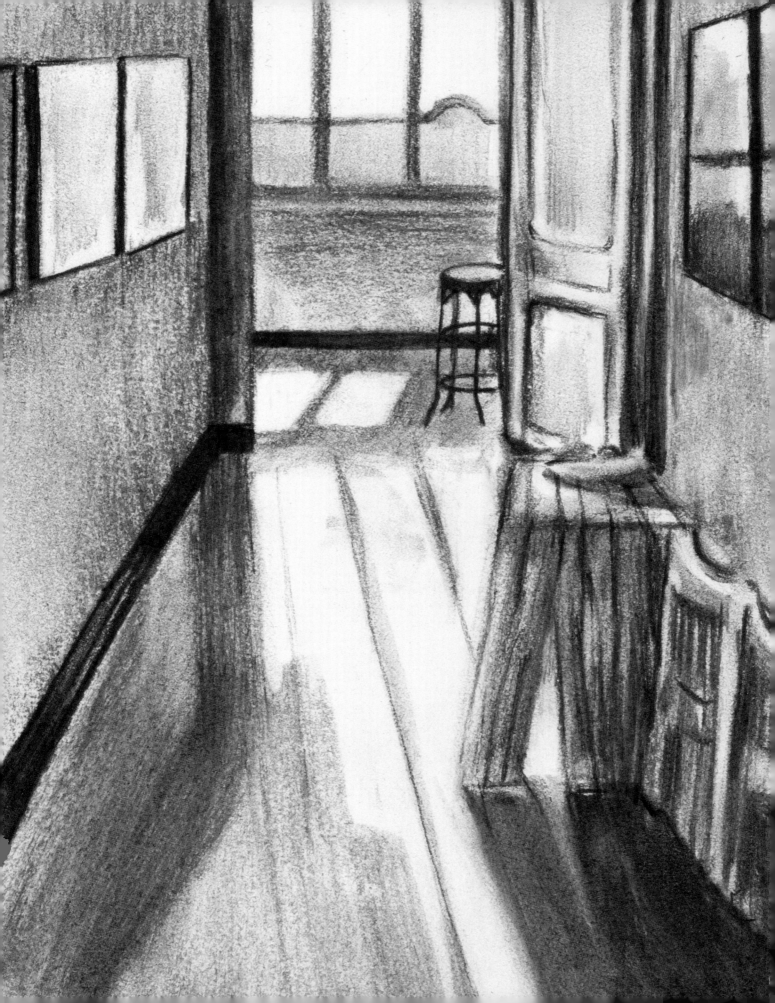

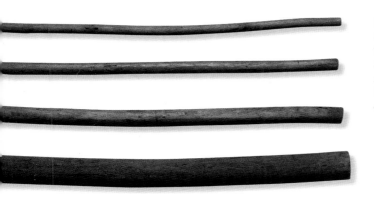

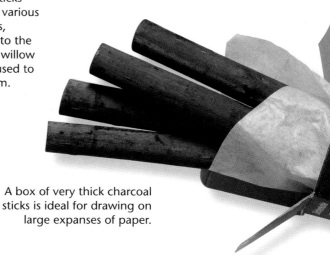

Charcoal sticks are sold in various thicknesses, according to the size of the willow branches used to create them.

A box of very thick charcoal sticks is ideal for drawing on large expanses of paper.

Charcoal

Charcoal is made from a piece of carbonized wood, sold in various thicknesses. It is an extremely raw medium—pure, direct, versatile, offering you a broad range of possibilities.

DIFFERENT TYPES OF CHARCOAL

As far as the quality of charcoal sticks is concerned, there are no major differences between the various brands. All require a high degree of quality, allowing you to produce nearly black strokes that will not scratch the paper or create inconsistencies. Nonetheless, some commercial brands offer four different levels of hardness.

THICKNESSES OF CHARCOAL STICKS

Charcoal sticks are sold in a wide variety of different thicknesses, depending on the diameter of the branches used to create them. They range from 3 or 4 mm to 7 cm in diameter. The diameter of the stick will determine the width of the stroke produced with it. However, it is also possible to create fine strokes with thick charcoal sticks if you draw with the edge at the stick's end. Some manufacturers offer square-shaped pieces of charcoal, which are quite handy for large-scale projects.

To produce the proper shading effect, it is fundamentally important to sculpt, or blend, the smudges of charcoal with your fingers.

IDEAL FOR SHADING

Charcoal is a medium that is used exclusively to create drawings with very pronounced shading and tonal gradations. The stroke produced by it is steady, soft, and spongy. It can be used to heavily fill in areas of the paper; however, the particles of charcoal easily move with just the brush of a finger, and can be blended with a smudge stick. You can use the very edge of the charcoal stick to produce linear strokes, or drag it across the paper lengthwise to cover a broad area with a uniform gray value.

You can shade the page easily by dragging the charcoal stick across it lengthwise. This will allow you to create very deep shading and gradated effects.

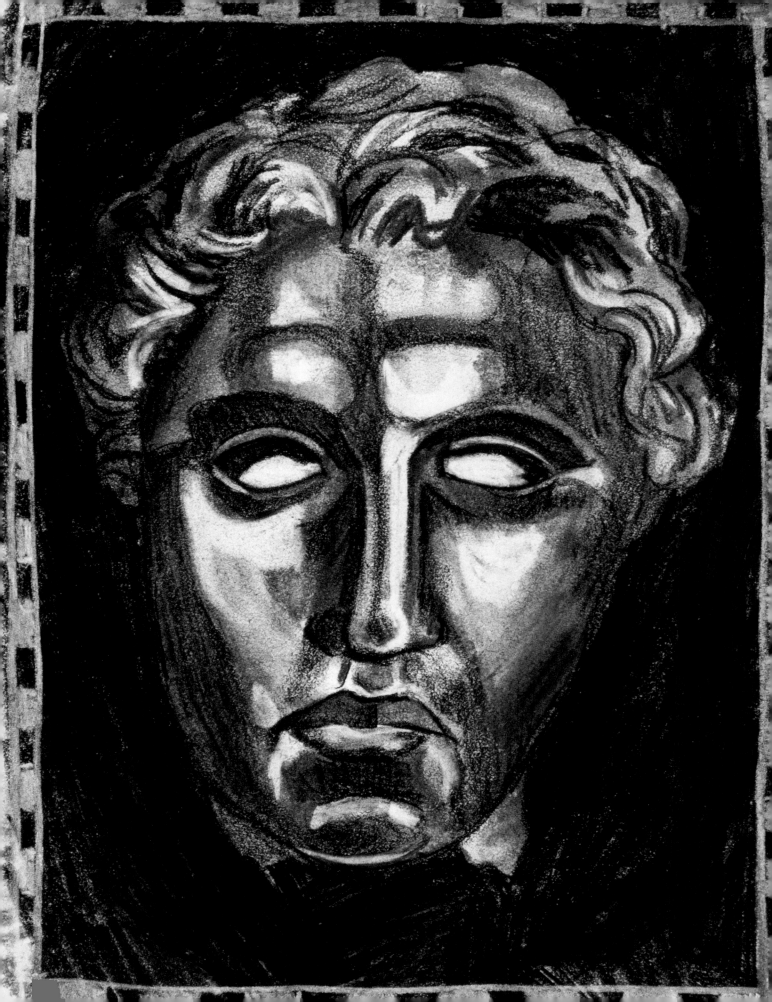

Compressed charcoal is made up of black pigment, a certain proportion of clay, and a binding agent.

Compressed Charcoal

Compressed charcoal is made by blending smoke-black pigment with a binding agent, which gives it a hard, stiff texture.

THE IDEAL COMPLEMENT FOR CHARCOAL STICKS

Compressed charcoal sticks are often cylindrical, and allow you to create a much more stable, intense, and granulated stroke than natural charcoal does. However, they are not as versatile for shading, and are harder to erase with a kneaded eraser. Natural charcoal is often used during the first stages of a drawing, while the compressed charcoal stick enters the scene toward the end of the process,

being used to intensify the drawing, darken shadows, and thus better highlight the contrasts inherent between light and shadow.

CHARCOAL PENCILS

These are made up of a "lead" of compressed charcoal encased within a cylindrical wood casing. As with graphite pencils, charcoal pencils vary in hardness, allowing you to create strokes of varying intensity. They also allow you to produce more precise strokes than charcoal sticks. They are often used during the final phases of a project in order to bring out the outlines and touch up details; or to create small-scale drawings.

Compressed charcoal sticks are harder and more consistent than conventional charcoal sticks, which will allow you to create deeper shades of black.

PENCILS WITH CHARCOAL-GRAPHITE BLEND

For years, charcoal pencils held a privileged place in the toolbox of many an artist. Lately, however, many have come to substitute them with a sub-category of this product: pencils made with a blend of charcoal and graphite, soot, or pigment. These make it easier to sharpen the tip to a fine point, and make it possible to obtain a different range of tones than those produced by conventional charcoal.

Three different forms of compressed charcoal are available: wood-encased pencils, woodless charcoal pencils, and sticks. When combined, they will allow you to create a rich variety of different strokes.

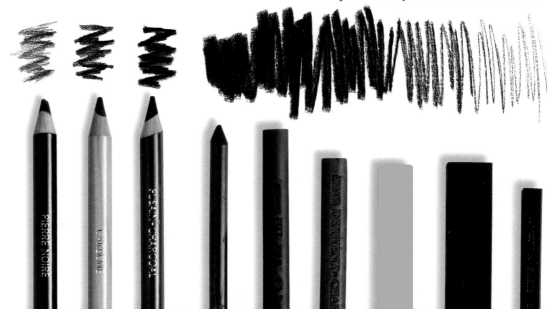

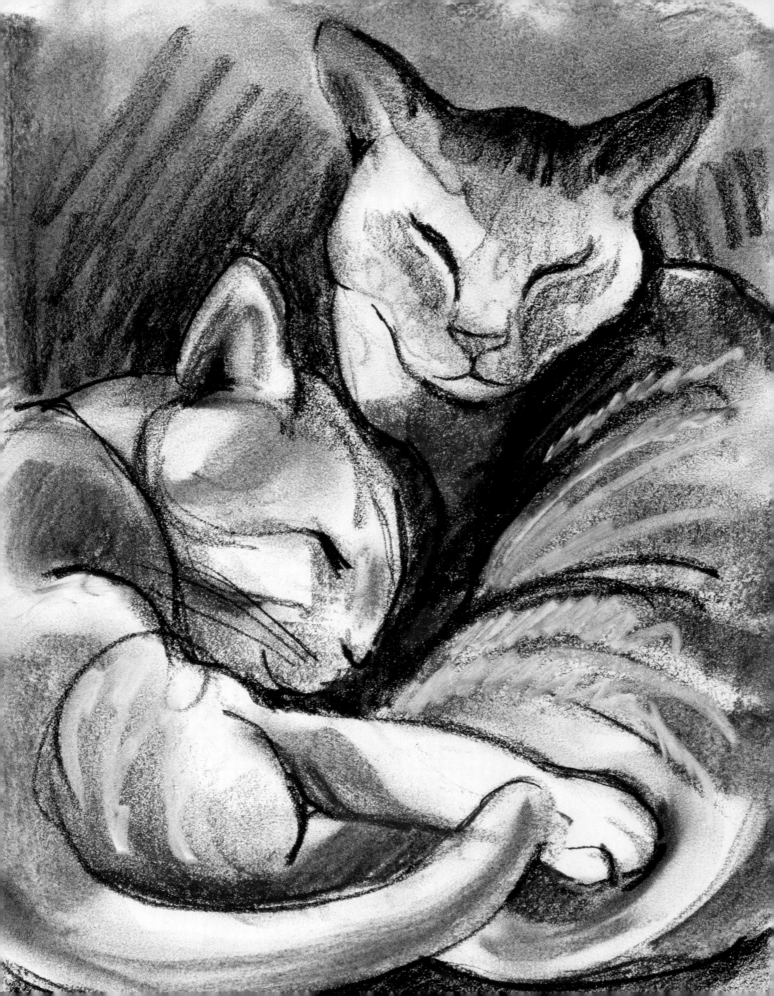

Chalk comes in various colors. The most common are black, brown, sanguine, and white. These are excellent for developing the tones and shading of a drawing.

Varieties of Chalk

CHALK
Chalk comes in sticks and pencils of varying hardness, made with pigment and a binding agent. Chalk is available in a wide range of tones, from black to varying shades of brown, which can all be used to create traditional shaded drawings.

USING CHALK
Chalk is an elegant, delicate medium. Its soft consistency makes it possible to blend colors with strokes or fine shading, developing lines and strokes that can accumulate in hatching patterns to produce compelling shading effects. In addition, these strokes can be blended together by simply rubbing a rag or smudge stick across them.

SANGUINE
Sanguine is a reddish-brown chalk with a color between rust and terra-cotta red. The color is highly valued by most artists for the warmth of its pigment, especially when it is combined with other drawing media. It allows you to create drawings with a warm coloration, a nice alternative to the more conventional tones of natural charcoal's intense gray and the deep black of compressed charcoal.

All chalks mix well with each other, and with natural or compressed charcoal. This will allow you to create high-quality shades and blending.

WHITE CHALK
This white color is made from a pigment bound with clay and, depending on the variety, sometimes includes a small amount of powdered pumice. It is used to highlight drawings created with chalk or with conventional or compressed charcoal. Adding white chalk highlights to a shaded drawing serves to emphasize the effects of the light, and gives the composition a greater sense of depth.

Sticks, wood-encased pencils, and woodless pencils made of white chalk can only be used when the background paper has a medium to dark tone. Otherwise the strokes will not be visible.

Assortments of chalk pencils and sticks tend to include sanguine, despite the subtle differences between the media.

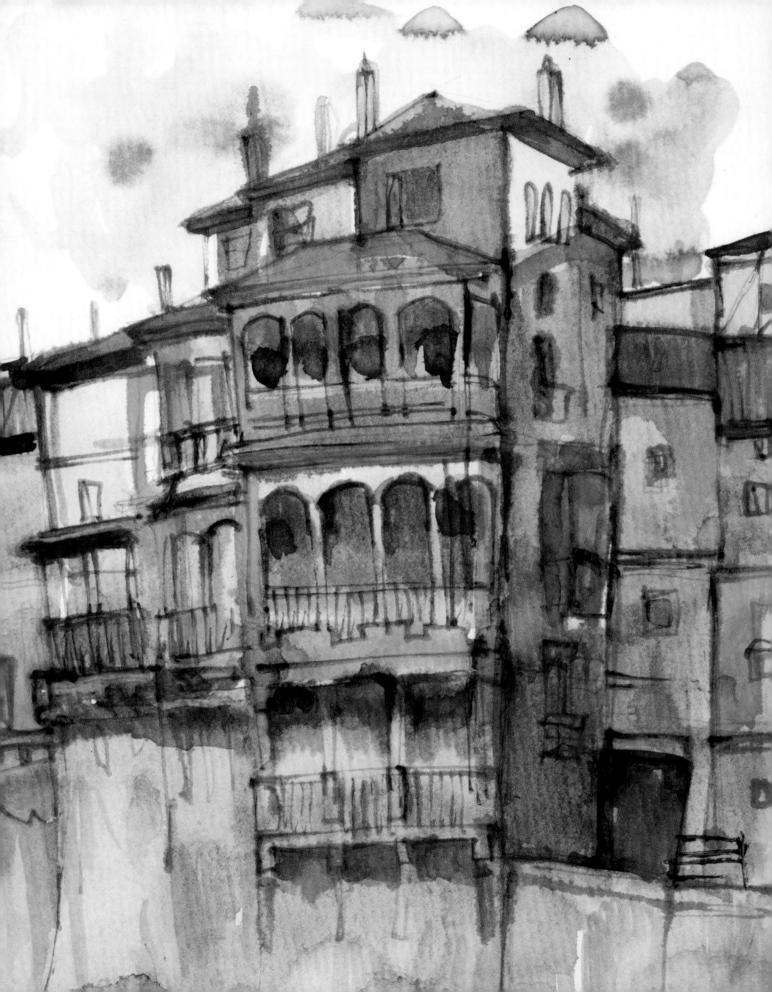

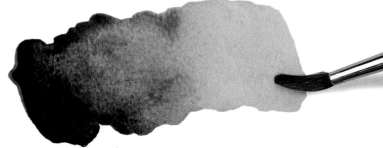

A wash made with India ink will give you plenty of opportunities for shading, from very intense black tones to more subtle shades of gray.

The more you water down the ink, the broader a range of gradient shades you will be able to produce.

Inks & Washes

Creating a composition with ink will give you the opportunity to combine interesting linear drawings with a strong sense of expression, thanks to the light and shadow effects that you can obtain with ink washes.

INDIA INK

India ink is an ink that is soluble in water. This makes it possible to vary the degree of concentration in order to obtain different tones of shading. You can obtain lighter shades of gray by diluting the ink with heavy amounts of water, making the wash more transparent and allowing more light to pass through. India ink is available in solid tablets or sticks that can be diluted by rubbing them against a special moistened rock, or in liquid form, sold in small glass bottles. Modern chemistry has provided us with alternatives to conventional black India ink, broadening the options to include other colors of India ink as well. These have a very similar composition, using colored dyes instead of black pigment.

SEPIA INK

The brown color produced by sepia ink will provide you with a great opportunity to work with shading and tonal effects. This ink was traditionally extracted from the ink sac of the Sepia cuttlefish. The substance would be dissolved in alcohol and artists would paint with a diluted wash of it. However, due to the fact that it was an organic substance extracted from a mollusk, it would quickly begin to ferment and give off an intense, foul odor. The sepia color that is currently used by artists is commonly made by mixing organic and inorganic pigments to reproduce the color and characteristics of the natural ink.

IT'S ALL ABOUT THE WASH

Working with ink depends on a simple, fundamental technique: creating a wash. To make a wash, you will load a wet brush with ink, apply it to your paper, and expand it with water to obtain the diluted color necessary. You can create shadows by allowing more or less of the white paper to show through the fine layer of color—the wash—that covers it.

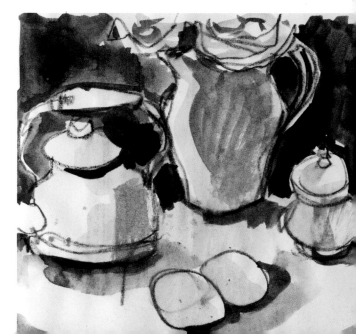

A composition made with ink can be a nice alternative to charcoal and chalk. The broad, colored areas will look denser, and the shaded areas will be much more solid.

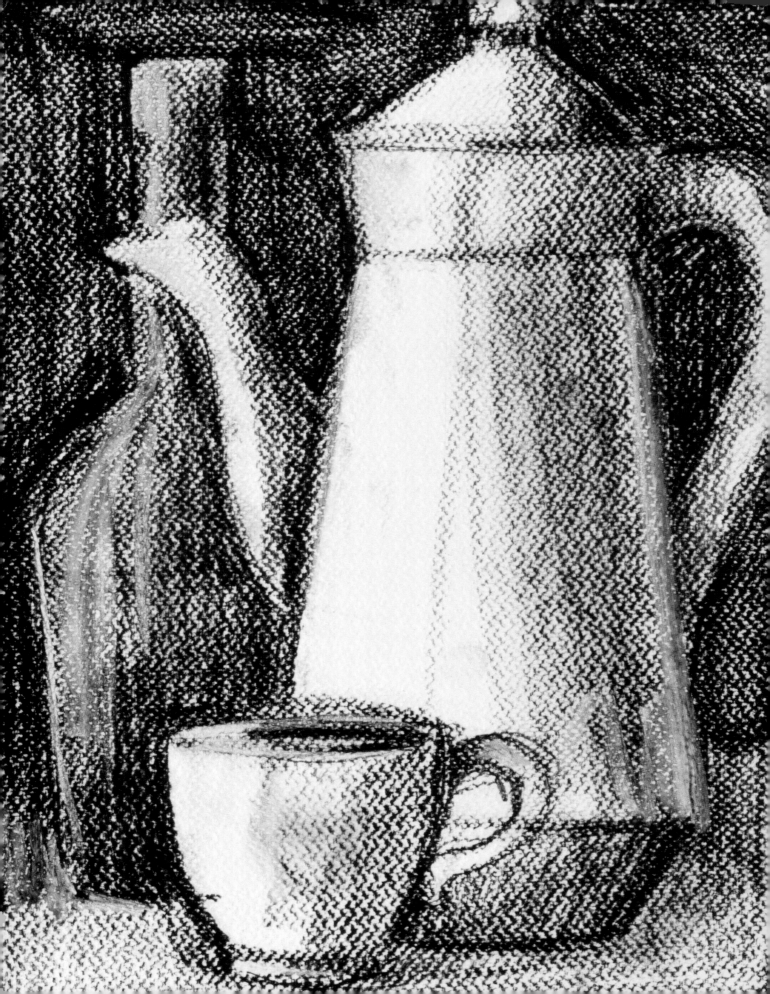

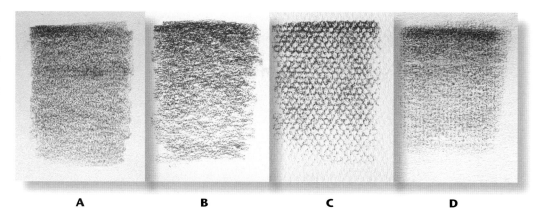

The effect of shading with dry techniques will vary depending on the type of paper (in order): (A) fine-grained, (B) medium-grained, (C) coarse-grained, and (D) laid paper.

A B C D

Selecting Your Paper

You will need to take the weight and texture of your paper into consideration, in order to create certain types of shading. It's a good idea to be aware of the basic characteristics of quality artistic paper before you decide on one type or another.

FINE-TEXTURED PAPER

Fine-textured paper is lightweight (between 60 and 200 grams), making it ideal for working with graphite pencils and charcoal. However, it can also give you good

There is an enormous variety of types of paper available on the market. For artistic purposes, you should look for high-quality brands or artisanal types of paper.

results when drawing with India ink (as long as your paper is not too lightweight). The thinner varieties of paper are easier to work with and provide you with a cleaner finish, with well-outlined shadows. They require a light touch, without pressing down too hard on the paper.

COARSE-TEXTURED PAPER

This type of paper is often used for expressive pieces where the artist wants the grain of the paper to show through, as it is difficult to completely color it in. Coarse-textured paper should be used only with charcoal sticks, chalk, and

derivatives; it is definitely not the right medium to use with pencil.

GLOSSY AND LAID PAPER

The grain is indistinguishable with these types of paper, as they have been hot-pressed to accentuate their smooth texture. These are the best types to use with graphite pencils. Laid paper has a medium grain and has a characteristic mechanical (laid) texture. This is the traditional type of paper to use with natural charcoal, compressed charcoal, or sanguine.

Working on coarse-grained paper will always provide a graphically interesting piece.

Techniques

The effect of light and shadow is obtained by creating a contrast between light and dark tones—through the way you represent shaded areas—that provides your drawing with volume, atmosphere, solidity, body, and a dramatic quality. The appearance of shadow creates a very painterly appearance, and reinforces the objective, tangible elements of the subject. In this section, we offer you very simple, effective, and basic strategies for drawing the shadow of any object. Beginning with basic shading techniques, we will show you how to further enrich your work with blends, gradient shading, and other key elements to properly create the effects of light and shadow.

Before you begin to lay out the shadows in your drawing, you should keep in mind that shading reinforces the tangible appearance of your subject, making it easier for the observer to grasp. In other words, the simple appearance of a shadow on any object creates the illusion of three dimensions. You can begin by practicing with very simple charcoal shading techniques, adding a few dark patches on one side of the object to represent the parts that are not in direct light. For your shading to be effective, you should leave the illuminated side of it blank; this will allow you to create a strong contrast between light and shadow, producing a very compelling graphic image.

1 The first step is to understand that shadows appear on just one side of an object—the side that is not in direct light. The initial layout of the shadows should be uniform.

2 During the second stage, shading can be gradually faded, since tones often vary and are not always uniform.

Basic Layout of Shadows

1

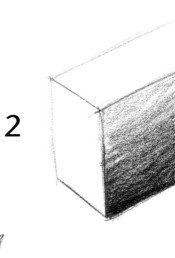

2

It is clear that the shadows on an object describe its shape, whether it is a curved or straight surface. In the early stages of drawing, they should be kept simple and basic.

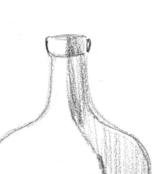

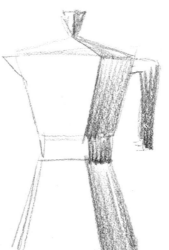

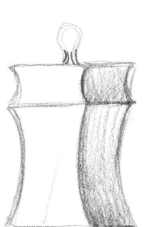

1

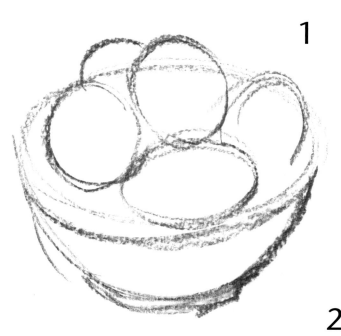

1 This still life is very simple: a bowl of eggs. Use the tip of your charcoal stick to draw the ellipsis of the bowl and half the circumference to lay out its base. Then incorporate the oval shapes in the upper part of the bowl.

2

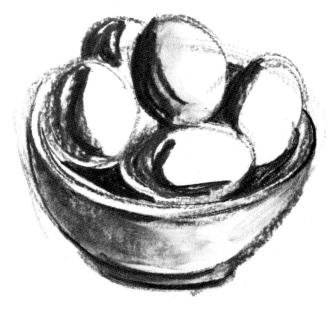

2 Use charcoal to shade in the left half of the bowl, and blend it with your finger. Extend each one of the shadows on the eggs with the tip of the stick to leave a thick, heavy stroke.

3 Carefully run your finger over each stroke, in order to make the shadow appear softer and not too exaggerated. Finish it off by drawing the cast shadow with a medium-toned gray. Notice how, with just a few different tones, you've already created a basic sense of volume.

3

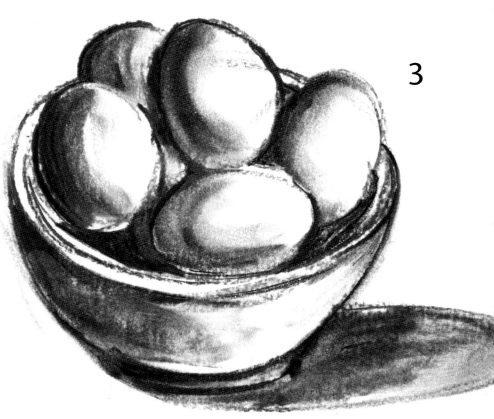

DO ⬆

Press down hard with the tip of your charcoal stick to make sure the charcoal dust sticks.

DON'T ⬇

Rub it with your finger too many times to smudge the shadow. One time is all it takes.

Tonal Synthesis with Charcoal

The simplest procedure for shading consists of working with a very small number of values. All you need are three or four tones, created with charcoal: one to represent intense shadow, another for medium-toned shadows, and another for lighter shadows. The last tone can be created by rubbing your finger across either of the other two tones of shading. Don't worry about nuances and superfluous details. The key is to summarize the details with broad, more or less homogeneous shadows. The lit areas are left blank; if they get smudged during the process of drawing, you can always whiten them again by erasing them with a kneaded eraser.

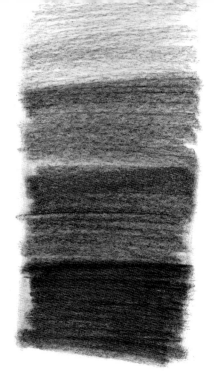

Four tones you can obtain with your charcoal stick by applying different amounts of pressure. The harder you press down, the more intense the shadow.

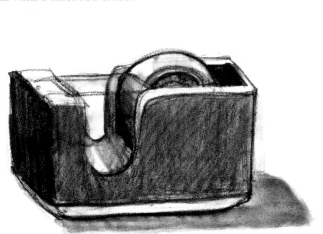

Simple objects require a simple treatment. This drawing contains just four different tones, if we include, as a tone, the parts of the paper that were left blank.

Tip
Use a thin charcoal stick for the strokes of the drawing, and a thicker one to shade in the larger areas.

In order to create an initial representation of a subject in light and shadow, leave the paper blank on the lit parts of the subject. Use a medium shade of gray for the shaded areas, which are complemented in some areas with a more intense black, to break up the uniformity of the gray.

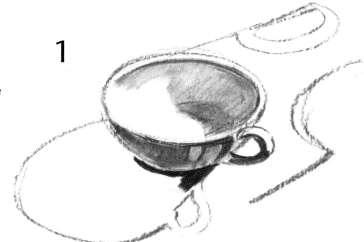

1

1 Use a thin charcoal stick to draw the shape of the cup with linear strokes. Apply light-toned shading to the inside and medium-toned shading on the outer edge. Carefully smudge with your finger.

2 Intensify the left edge of the cup with a very deep shadow, and finish the nuances of thickness to define the object. Use a thicker charcoal stick to darken the cast shadows, which are an intense black color.

2

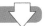

DO

Lightly rub your finger across the drawing after every new application of charcoal to blend it and make sure that there are no loose strokes left on the drawing.

DON'T

Touch the blank parts of the paper with your charcoal-covered fingers.

3

3 Press down hard with the charcoal stick to cover the cast shadows so that the pigment completely fills in the pores of the paper. To finish your work, rub your finger around the shadow to keep its edges from looking too clean-cut.

Smudging with Powdered Pigment

It is possible to create shading directly without drawing strokes by smudging the paper. Drawing with powdered pigment—created by rubbing a stick of charcoal or chalk against paper—is a great way to develop shading. You can also buy powdered pigment at many art supply stores. To work in this medium, you will need to prepare small cotton balls that you will use to rub on the powdered pigment. Once they are loaded with chalk or charcoal, you can begin to draw on the paper, sketching out the shape of your subject's shadows. This unique method, which will allow you to establish the drawing with faded tones rather than strokes and lines, makes pigment smudging a surprisingly simple method for learning the shading technique.

You can make your own powdered pigment at home by rubbing any stick of charcoal or chalk against a piece of abrasive, coarse-grained paper. Then all you will need to do is load a cotton ball with the powder and apply it.

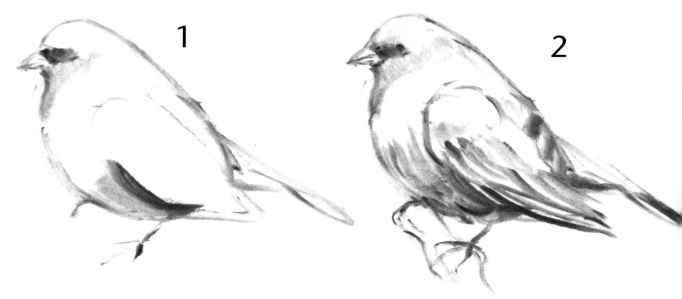

1 With your cotton ball loaded with powdered charcoal, make the first strokes that will define the outline of the bird. You don't need to press down hard—just enough to brush the paper with the cotton.

2 Complete the drawing with a smudge stick, overlapping various smudges until you obtain the textured effect of the wings. Develop the details of the bird's head with the tip of the smudger.

1

Use coarse-grained paper to rub the powdered pigment loose from the sticks of charcoal, chalk, or sanguine.

Create your drawing on a piece of light-grained paper, and don't press down too hard.

1 Here, we will be combining the techniques of powdered pigment and light strokes. Use a stick of chalk to sketch out the shape with linear strokes. Develop the shading with a piece of cotton loaded with powdered sanguine.

2

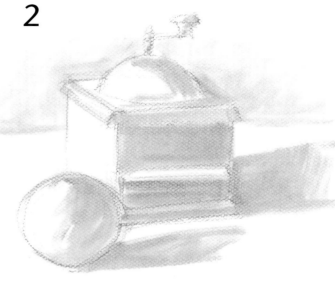

2 Add new elements with the sanguine-loaded cotton, until the shaded areas are well differentiated from the lit areas. If necessary, go over the blank areas with an eraser.

3

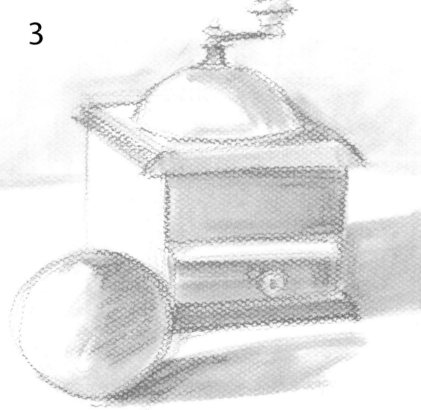

3 For the final touches, use the sanguine stick. This is to intensify the heaviest shadows and recover some of the strokes that may have been lost when smudging with the cotton ball.

One of the simplest ways to begin shading is by working with just a few tonal values. Two or three tones should be enough: one for the light shadows, one for the medium shadows, and a third for the darkest ones. Apply your shading in a level, uniform way, assigning values to each area according to the intensity of the shading. The shadows in your drawing will become building blocks that you use to structure the shape of your linear drawing and make it more solid.

1

Dividing Areas According to Tone

1 Cardboard boxes are excellent subjects to use for practicing tonal division. Use a brown-colored pencil to create a linear drawing of the subject, paying careful attention to perspective.

2

2 It is a good idea to practice creating tonal scales like this one, to test out your pencil ahead of time and see what levels of intensity and depth it can create.

3 Each flat surface of this box has a different degree of shading, depending on how much light hits it. The combination of all these tonal areas, which fit together like a puzzle, is what will describe the volume of the subject.

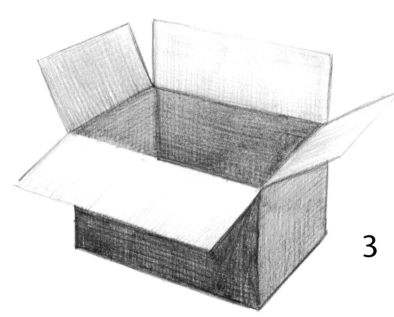

3

Tip
Establish the definitive tone of each area, in comparison with the others, by applying several very fine layers of color.

1

1 Tonal division can be very handy when the subject you are depicting has a geometric shape. Begin by creating a linear drawing with your graphite pencil, applying an initial layer of very light shading.

2

2 Add a second shade of stronger gray to the surfaces of the bricks that are not exposed to light.

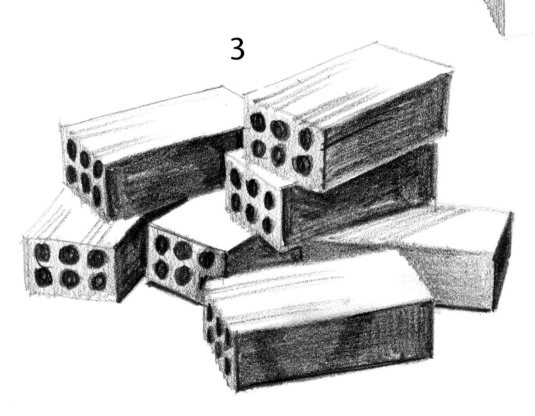

3

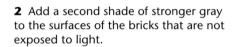

3 Leave the lit areas of the bricks blank. Finish by adding details that will help to identify the subject depicted, such as holes or grooves.

The Values in Gradation

A gradated effect, whether it is made with graphite, charcoal, or colored pencils, can be easily created by laying the flat stick or the tip of your pencil lengthwise across the paper. Drag it back and forth across the paper, pressing down more and more lightly as you go. The result will be a gradation with a very dark tone in the beginning that gets progressively lighter. This sort of gradation is the main tool an artist has to depict the transition from light to shadow; it may be light when the object is well lit, or abrupt and stark when the shading effect is very intense and dark.

A simple gradation made with charcoal is enough to give this cup a sense of volume.

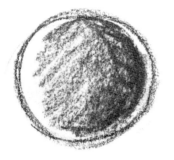 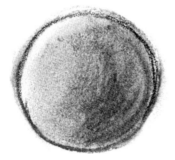

A drum is a cylindrical object that can be shaded with just one gradation.

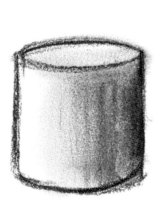 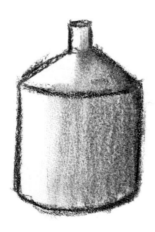

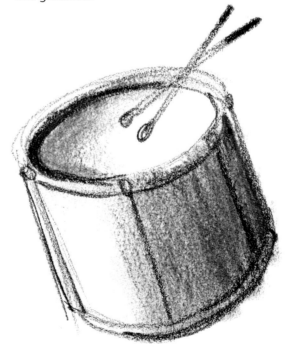

A gradation is created by shading progressively, from light to dark. It is especially effective for spherical and cylindrical surfaces. You can soften the gradation by smudging it with your fingers.

Tip
Practice creating the gradation on the margins of your paper to get to know the possibilities and intensity that your drawing tool offers.

The extension of soft gradations across the surface of an object helps emphasize its volume, even when they are distributed at random.

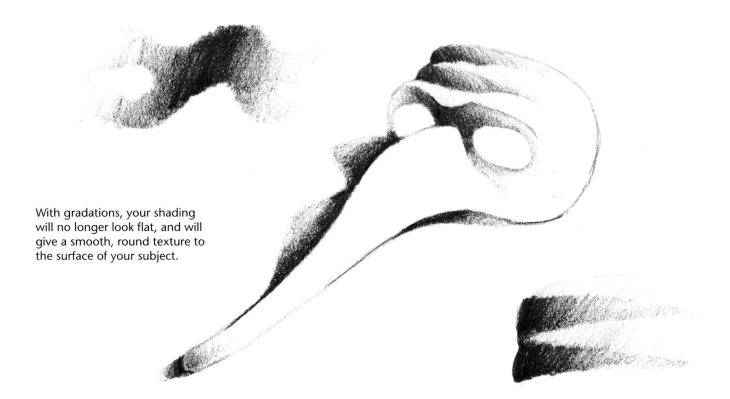

With gradations, your shading will no longer look flat, and will give a smooth, round texture to the surface of your subject.

Shading Negative Space

To work in the shading of an entire piece, it is not enough to incorporate only the shadows of an object. The success of your drawing often depends on establishing the relationship with its background, using what is known as "negative space." In other words, the air surrounding the subject. For this reason, in order to understand the different shapes involved, you will need to be able to identify and contrast, when applicable, the "countermold" of the figure. When you intensely shade the background of your drawing, it will bring more light to the subject, in addition to outlining its overall shape.

Dark shading in the background helps to better describe the subject, especially when it is well lit.

1 Shading in the negative spaces can be a great strategy for detailing complex subjects, such as this bicycle.

1

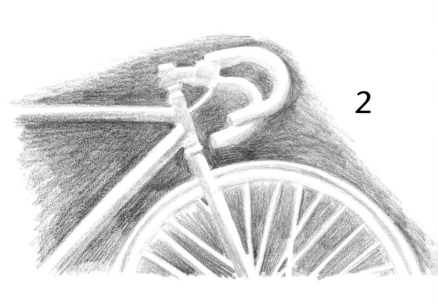

2

2 The darker the background is, the lighter the object in the foreground will appear, and the more visible the shadows along the frame of the bicycle will be.

1 Use a brown-colored pencil to draw the outline of the chair; then begin to shade in the "countermold"—in other words, the blank spaces surrounding the figure.

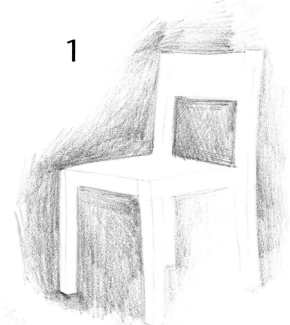

2 In order to give the background the necessary intensity, use two tones of brown-colored pencils. The subject's shape is now clearly visible.

3 Finish by incorporating the shadows on the subject itself, using much softer, lighter tones than the dark tones that dominate the background.

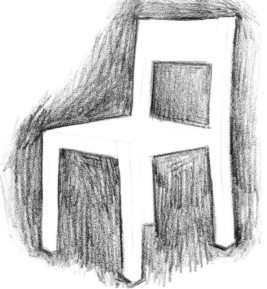

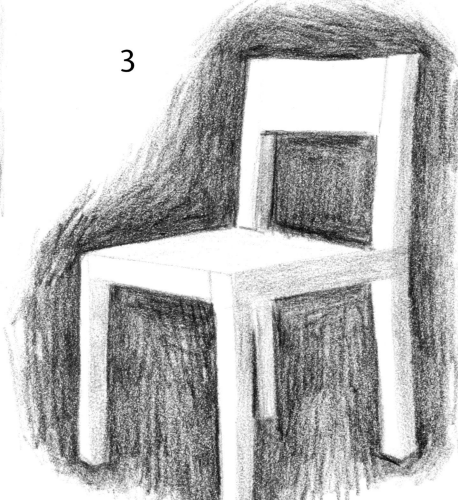

Tip
Shade in the background first, rather than starting with the subject. This also makes for a good practice exercise.

Sculpting

This technique is commonly used by artists who hope to recreate the rounded, voluminous shape of their subjects. Sculpting allows you to depict the sculptural corporeality of your subject, creating an almost tactile effect that suggests how the shapes in your drawing twist, turn, and occupy a deep space. You can achieve all of this through shading, using soft gradations that can be smudged by hand or with a smudge stick. The best way to begin sculpting is by using very soft tones—which do not contrast too sharply with each other—and noticing how the effect of depth and form is accentuated with every new shade applied.

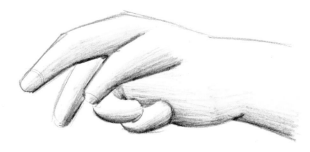

To make your drawing appear more three-dimensional—or more solid—begin by sculpting its shapes with gradated shading. This gradation will create a strong sense of volume.

Then make the shading progressively more intense, blending it with the smudge stick or with your fingers. The sculpting should serve to describe the tactile quality of the skin's surface.

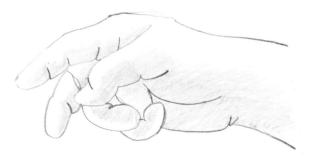

Sculpting is based on the proper description of the shape that is visible in the human form, using soft transitions in tone, or gradations. Begin by applying soft shading to this drawing of a hand.

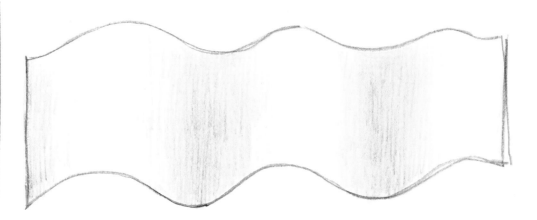

Try to use sculpted shading to depict a simple figure—such as a draped sheet of fabric. These soft, shaded transitions are fundamental for depicting flowing contours.

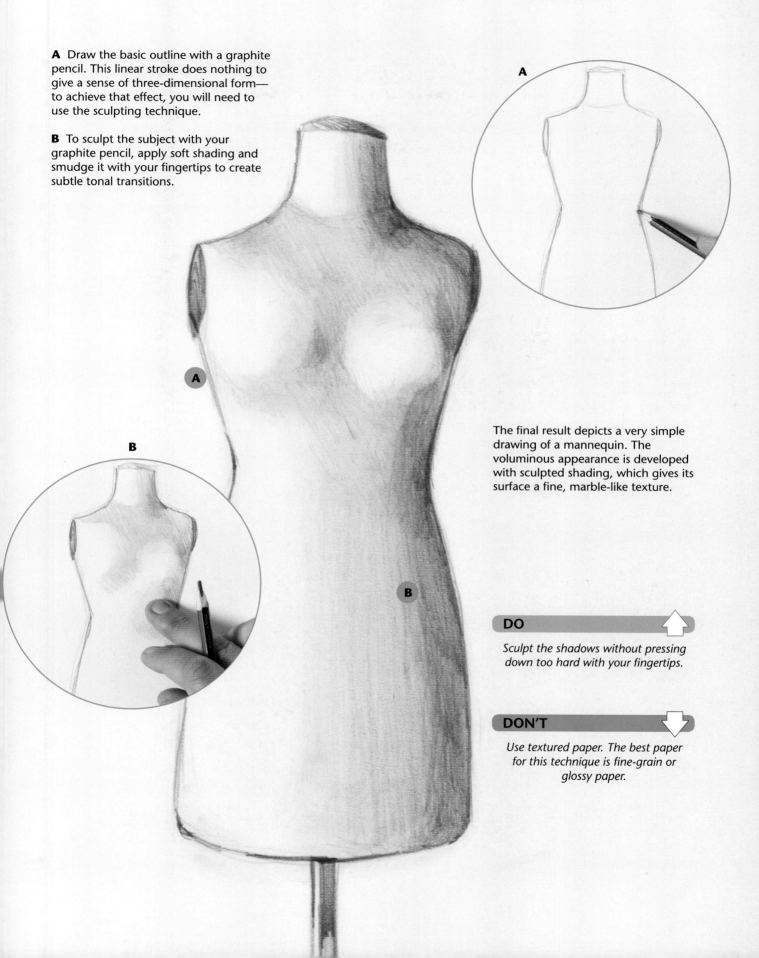

A Draw the basic outline with a graphite pencil. This linear stroke does nothing to give a sense of three-dimensional form—to achieve that effect, you will need to use the sculpting technique.

B To sculpt the subject with your graphite pencil, apply soft shading and smudge it with your fingertips to create subtle tonal transitions.

The final result depicts a very simple drawing of a mannequin. The voluminous appearance is developed with sculpted shading, which gives its surface a fine, marble-like texture.

DO

Sculpt the shadows without pressing down too hard with your fingertips.

DON'T

Use textured paper. The best paper for this technique is fine-grain or glossy paper.

Just as you can depict a subject using only lines, you can also draw your subject using nothing but shading. For instance, it's possible to make a drawing that consists solely of broad charcoal smudges, with no linear strokes at all. The goal of this exercise is to create a simple, limited image—effectively juxtaposing light and shadow with slight gradations—in such a way that, in the end, the shadow effect produced by the shading will cover up the initial line drawing and give it a painterly appearance. The scale of values here is very broad, and some parts of the drawing contain strong contrasts. Its edges, on the other hand, fade away into a shady atmosphere that blurs the shapes in the drawing.

Shading with Diffuse Borders

1

2

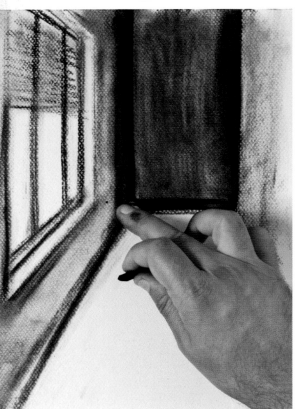

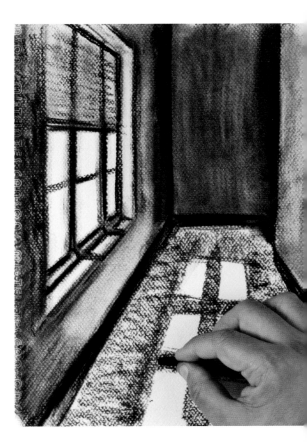

1 Draw this indoor scene with charcoal, developing a broad range of tonal shading with diffuse edges. Use your flat charcoal stick, smudging the walls with an initial layer of shading.

2 As you apply new layers of shading, smudge them with your fingertips. The idea is to create intense tonal areas on the back wall and around the window.

3 Progressively darken the interior space, leaving the areas that are in direct light blank.

3

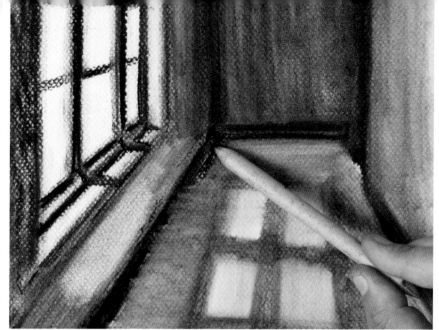

4

4 Eliminate the strokes of the charcoal stick with a smudge stick, making the shadows more dense and blending the edges of the distinct tonal areas.

5

DO ⬆

Press down on the top end of the charcoal stick to avoid accidentally creating undesired strokes.

DON'T ⬇

Press down too hard with the smudge stick. All it takes is a light brush to scatter the charcoal dust.

5 The end result is an indoor space described by the shaded effect of how the shadows interact with each other. This is made possible by the fact that the borders between the shaded areas are not clearly marked and, in many places, appear to mildly blend together.

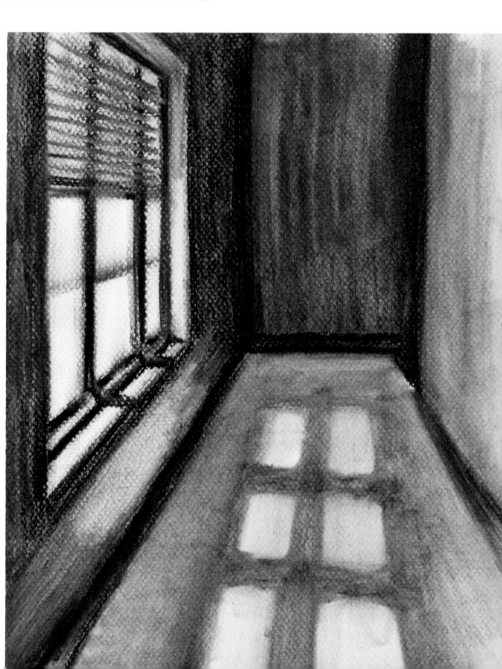

Based on what you learned in the previous section, it should be very easy to create an atmospheric drawing. All you need to do is push the gradated edges to their limit, blending tones and fading the edges of the most intense and contrasting smudges. While atmospheric shading is especially suited to landscapes, it can also be used to create a shadow effect in a still life composition. The shapes of the objects in the composition become less defined with shading, but they can still be made out through the differences between light and shadow. Your smudge stick will come in quite handy for controlling this effect, although your fingertips will be quite useful as well.

Diffuse shading, described in the previous section, is created when the outline of the subject appears lightly faded, without sharp lines.

The diffuse shading obtained with an ink wash is considered to be "atmospheric" when the physical shapes of the objects blend so much that they appear to run into one another.

Creating Atmosphere

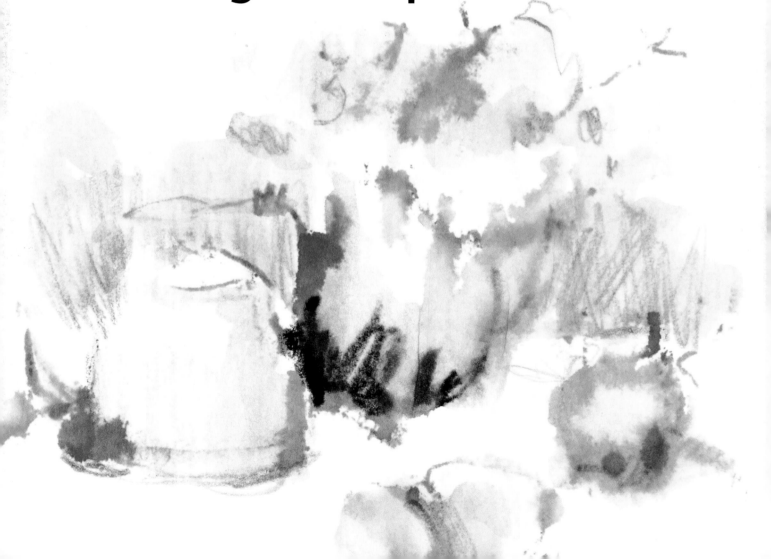

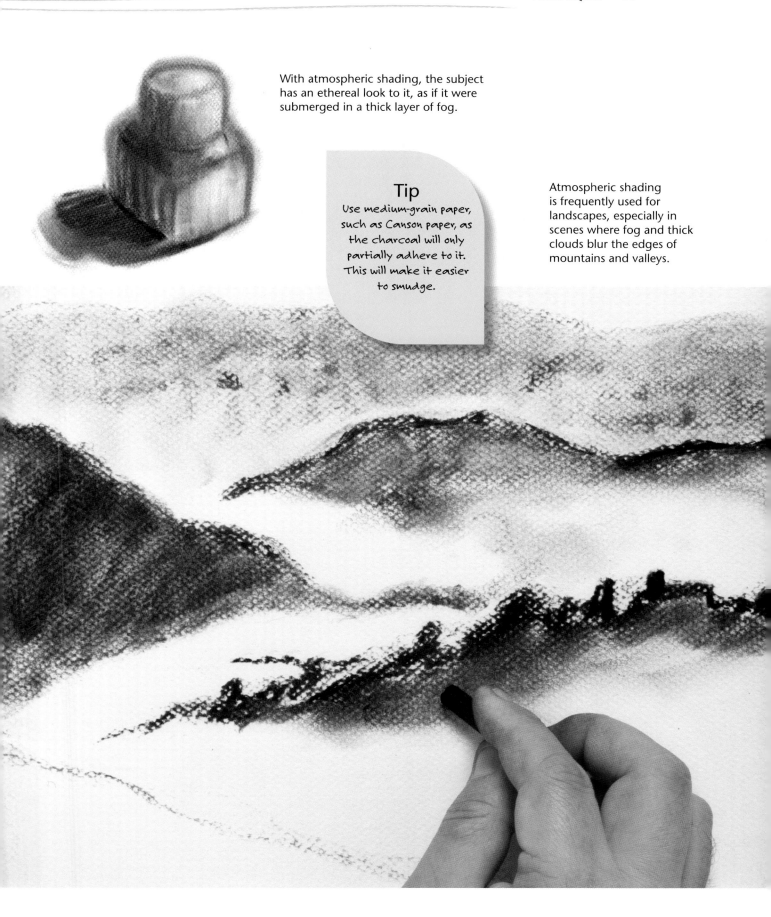

With atmospheric shading, the subject has an ethereal look to it, as if it were submerged in a thick layer of fog.

Tip

Use medium-grain paper, such as Canson paper, as the charcoal will only partially adhere to it. This will make it easier to smudge.

Atmospheric shading is frequently used for landscapes, especially in scenes where fog and thick clouds blur the edges of mountains and valleys.

Solid Shading

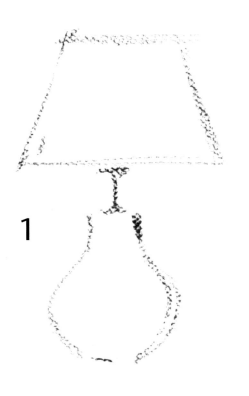

1

Shadows often recreate the outline of a shape. One good way to depict them is by drawing solid shadows, blocked out with one dark color, making them intense and more or less the same. This will help to clearly establish the particular shape and distribution of the cast shadows. All you need to do is draw dark patches corresponding to the shaded areas, focusing only on their shape and the markedly contrasting effect created by them. Solid shading is equally effective on both white and dark backgrounds; a dark background will reduce the strength of the shading, but will also serve to emphasize the effect of the areas in light. Solid shading is often applied to opaque objects to give them a more solid appearance.

1 Start by practicing on objects that are familiar to you—in this case, a simple charcoal line drawing of a lamp.

2 Use a lilac-colored bar of chalk to mark off the shaded half of the lamp, and fill it in with simple zigzag shading, pressing down very lightly.

2

3 If you work with the tip of the chalk, you will give the shadow more density, without simply creating a flat shaded area. The idea is to develop the values of the composition.

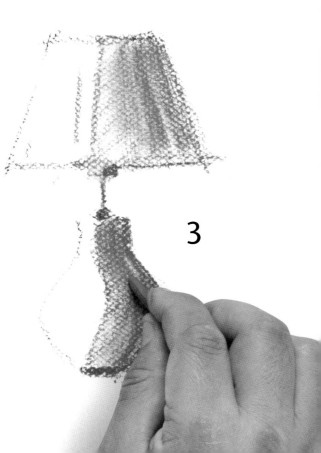

3

1

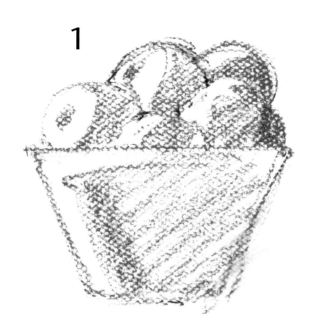

1 When drawing this basket of fruit, the first step is to map out the shaded areas.

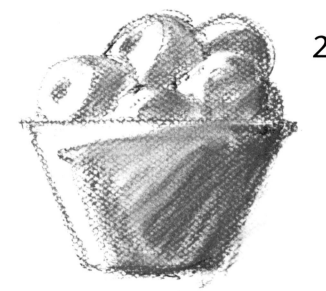

2

2 The second step is to give the shading body and solidity, making it contrast with the well-lit parts of the subject.

Three pieces of fruit with solid shading, drawn with two colors of chalk: royal blue and lilac. The dark background makes the illuminated areas stand out, as well as emphasizes the shape of the fruits with contrast.

DO	DON'T
Experiment with using different colors to shade your drawing. Don't limit yourself to just black and brown.	Create completely flat shaded areas when using solid shading. You can obtain both solidity and tonal variety at the same time.

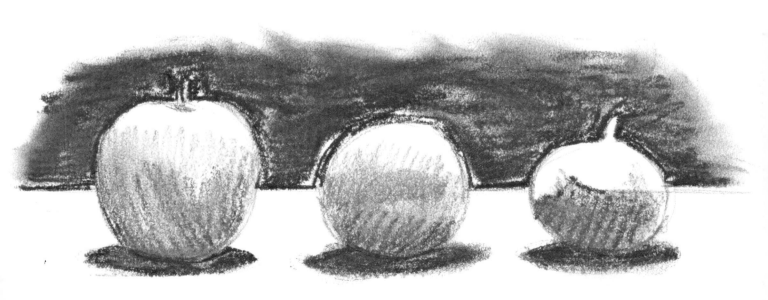

Shading & Simultaneous Contrast

This exercise has to do with adequately shading a drawing or painting, with the general idea of giving it a sense of three-dimensional form and greater expression. To achieve this effect, you will have to properly depict the contrast between light and shadow. This effect can be reinforced by applying a dark color to the background, as this will affect the intensity and tones of the shading, giving them a clearer, darker look than if they were on a blank background. This technique is known as "simultaneous contrast," which creates the sense that a single tone of shadow does not have independent significance; rather, the shadow is interpreted based on the intensity of the tones surrounding it.

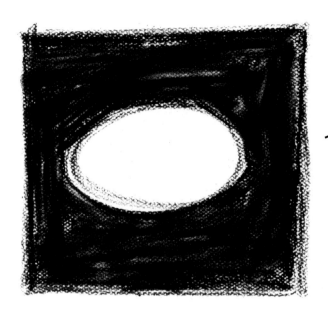

1

1 Darkening the background surrounding the subject does much more than just establish its outline—it clearly affects the way we will perceive the shading in the end.

2 Do an experiment: draw an oval shape and shade it in with charcoal, applying soft strokes that you will fade with your fingertips.

3 The shape acquires volume, which is now visible thanks to the shading effect. The intensity of the shadows against a blank background is adequate, but...

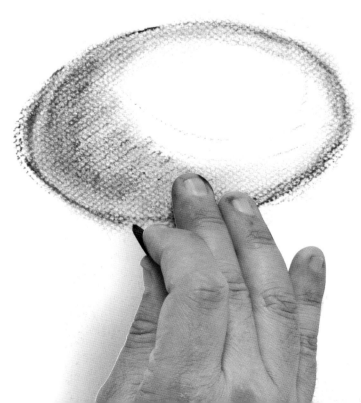

2

3

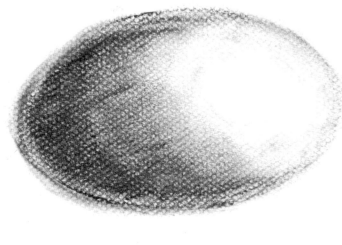

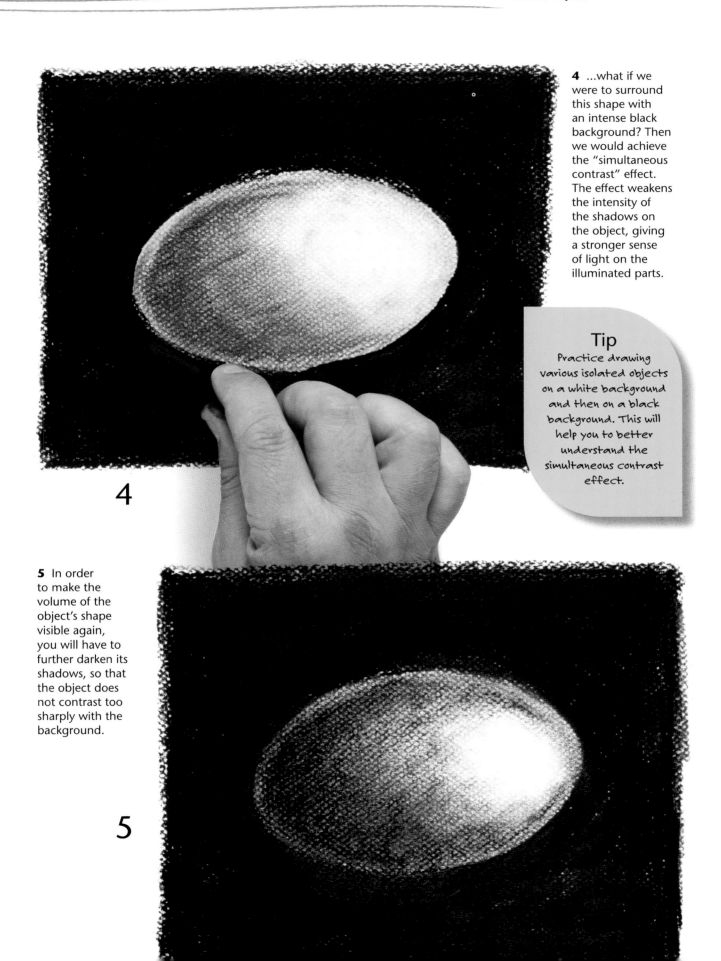

4 …what if we were to surround this shape with an intense black background? Then we would achieve the "simultaneous contrast" effect. The effect weakens the intensity of the shadows on the object, giving a stronger sense of light on the illuminated parts.

Tip
Practice drawing various isolated objects on a white background and then on a black background. This will help you to better understand the simultaneous contrast effect.

5 In order to make the volume of the object's shape visible again, you will have to further darken its shadows, so that the object does not contrast too sharply with the background.

4

5

Classic Light & Shadow

The classic light and shadow effect is created when natural or artificial light hits a body from a lateral, and typically elevated, source. This clearly differentiates the area directly hit by the light from the dim area (the intermediate space between light and shadow) and from the shaded area (which is not illuminated at all). The correct application of the technique will emphasize the subject's volume and give more life to your drawing. Take a look at some of these very simple examples, which will also help you practice darkening the area around an object, as described in the previous section.

1

1 Practice the shading technique by drawing a real subject—a pear—with two colors. First, draw the subject with a sanguine stick. All it takes to establish its shape is a silhouetted line.

2

3

2 Use the sanguine stick to do the initial shading. Then blend it with some charcoal. This will give your shading a solid quality that will emphasize the areas in light.

3 Darken the background with your charcoal stick. Use heavy strokes to make sure that the paper's grain is completely filled in with a thick layer of black.

4

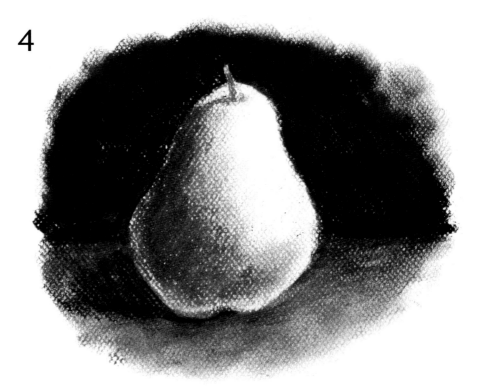

4 Darkening the background will cause the values of the fruit's shadows to appear more intense, embellishing the shading effect in relation to the outline.

DO	DON'T
Silhouette the object with a dark patch to give depth and definition to the background.	*Work too much on the shadows or try to describe too many details. The key to success lies in simplicity.*

Based on this very simple way of developing light and shadow, you will be able to choose new subjects that will offer you increasing levels of difficulty and complexity.

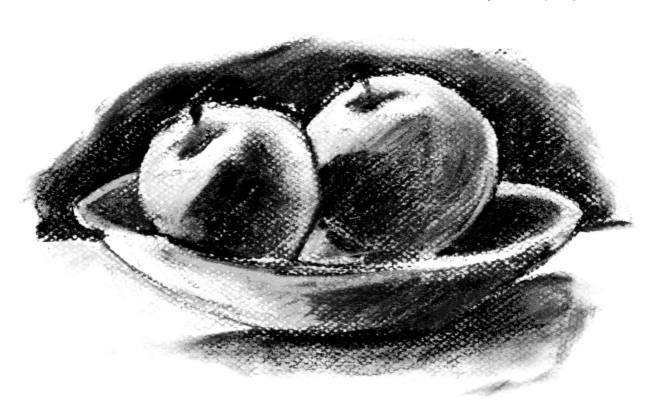

The effect of the shading here is so light that it can be created with just a slight brush of the pencil against the paper.

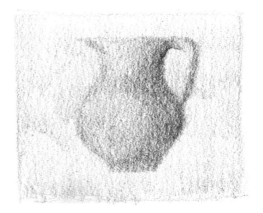

Light-Toned Shading

You can rule out charcoal for this type of drawing, since it creates strokes that are too intense for this effect. Use graphite pencil instead, as this is the best medium for this particular style of shading.

At some point, all of us have come across a drawing with very light, barely perceptible shading. A drawing that looks almost too well lit. These are pieces that use the light-toned shading effect—in other words, drawings in which the dominant tone is based on heavy illumination; drawings that contain soft gray, rather than pure black, tones. It is common for this type of shading to be used when you want to create a soft, ethereal environment. When using this method, your shading will have a delicate look, and your drawing will appear semisolid and evanescent.

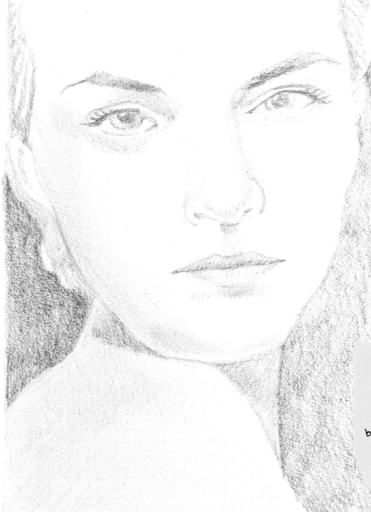

Graphite drawing using the light-toned shading effect. The areas in full light use the blank white color of the paper.

Tip
Depict your subject against a blank white background when working in light-toned shading.

To make these drawings effective, you will have to plan your composition properly: your elements need to be bathed in soft, dim light, avoiding strong contrasts.

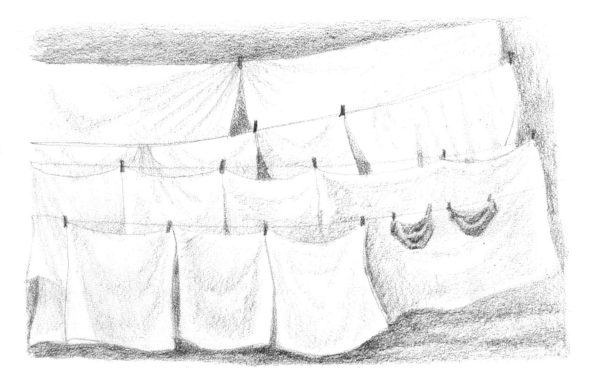

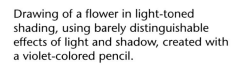

Drawing of a flower in light-toned shading, using barely distinguishable effects of light and shadow, created with a violet-colored pencil.

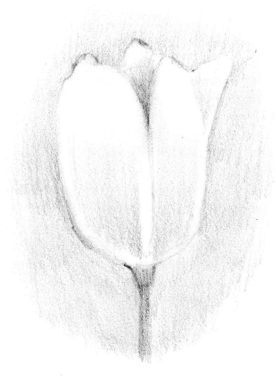

If you prefer to create light degrees of contrast, you can incorporate soft gray elements with your graphite pencil.

Dark-Toned Shading

With dark-toned shading, artists use a minimal amount of light, distributed strategically, and applied only to the most outstanding, interesting parts of the subject. This type of drawing predominantly involves very intense, well-defined shadows. For this reason, in order to represent your subject in dark-toned shading, you will need to be sure that you have a medium-toned or dark-toned background, in order to ensure that the areas in light are clearly visible and appear as true highlights.

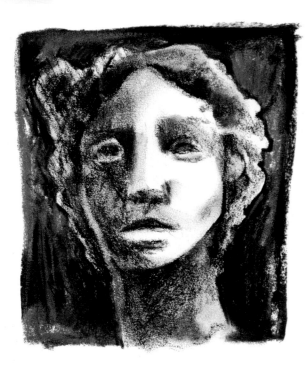

1

1 Chalk and charcoal are used for dark-toned shading, as they are the most effective tools for creating the darkest shading.

2 You need to make sure that there are areas that are dark enough to emphasize the brightest details.

3 The shadows that establish the most dramatic contrast should be emphasized, especially with portraits.

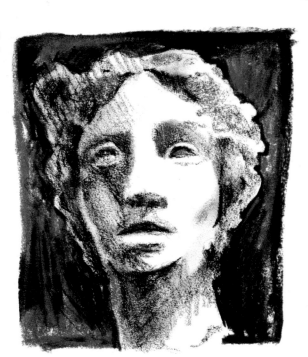

2

3

1

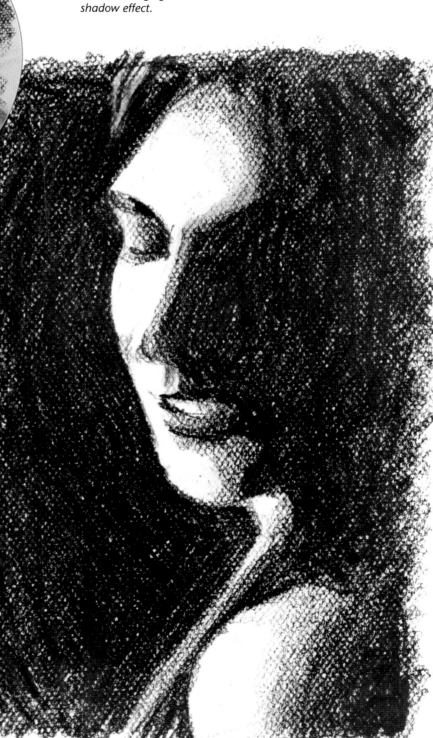

DO	DON'T
Take care with your composition and layout when selecting the areas that will be heavily lit, making effort to create an interesting light and shadow effect.	*Select dark-colored subjects, as light-colored subjects will provide you with a more dramatic contrast.*

If you choose to work with graphite, it's preferable to use soft-leaded pencils, such as 4B, 6B, or even 8B.

2

The best subjects are those that have dark backgrounds and are sparsely lit, but which also allow you to imagine provocative forms, in which light glimmers or is reflected in a notable way.

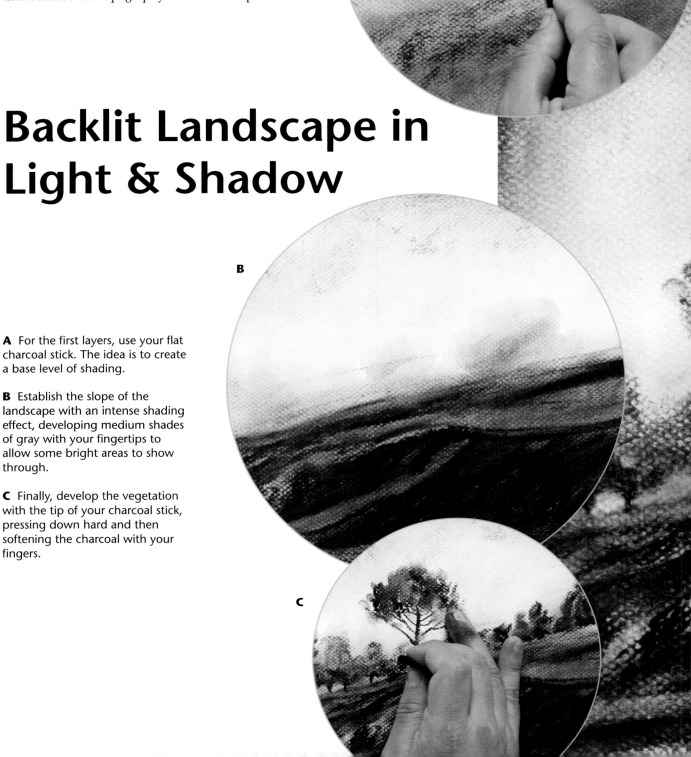

This exercise shows how to develop a dark-toned landscape with strong backlighting that vividly darkens the objects in the foreground. The light and shadow effect is developed progressively with charcoal, building on itself, overlapping various gradations on top of each other, until you achieve the greatest possible contrast in tone between the bright expanse of the sky and the dark areas of vegetation, which includes subtly lit areas that describe the topography of the landscape.

A

Backlit Landscape in Light & Shadow

B

A For the first layers, use your flat charcoal stick. The idea is to create a base level of shading.

B Establish the slope of the landscape with an intense shading effect, developing medium shades of gray with your fingertips to allow some bright areas to show through.

C Finally, develop the vegetation with the tip of your charcoal stick, pressing down hard and then softening the charcoal with your fingers.

C

Tip

When manipulating an intense shadow with charcoal, softly rub it with your fingertips to smudge or blend it, or press down hard with a clean finger and drag it across the paper to create medium tones.

The result will be a natural landscape scene with a marked shading effect, containing dark, contrasting shadows.

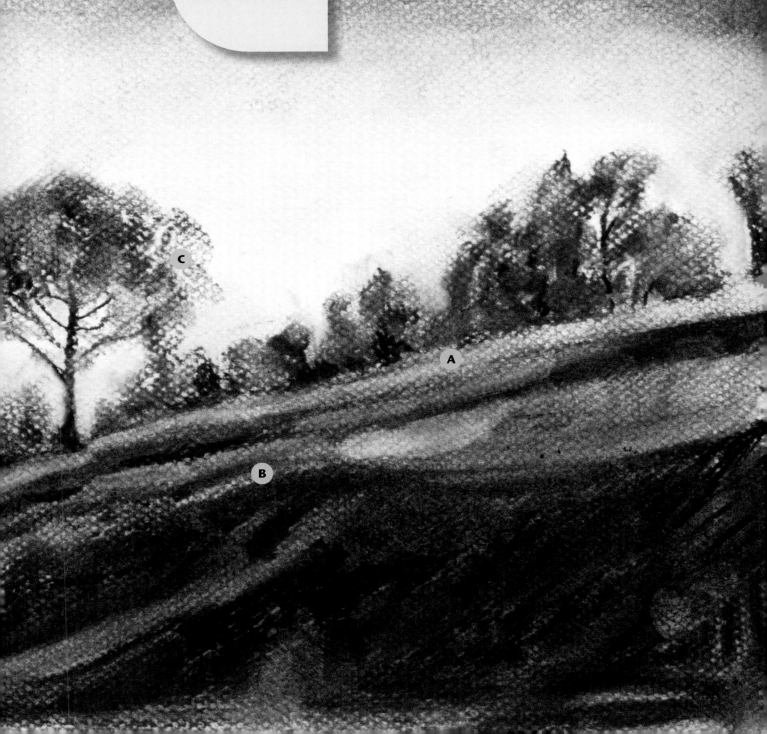

1 Draw the outline of this pepper with a very light stroke, and then fill it in with a brown watercolor wash. Once it has dried, you can shade it in with charcoal.

This technique provides a shadow effect with strong contrasts between the areas in light, highlighted with white chalk, and shaded areas, established with deep black shades of natural or compressed charcoal. In order to make the most of the contrast between white and black tones, you should work with colored paper or cover it first with a medium-toned glaze of watercolor. The medium tones that can be achieved with brown-colored watercolors will make the shading effect stronger, and soften the transition between such opposing colors.

1

Shading with White Highlights

2 Add the highlights with white chalk, which will incorporate the shiny effect of the light and depict the characteristically glossy texture of the pepper.

2

DO ⬆	DON'T ⬇
Practice sculpting in order to depict your subject as realistically as possible.	*Overuse white highlights. In order for them to be effective, they need to be precise and limited.*

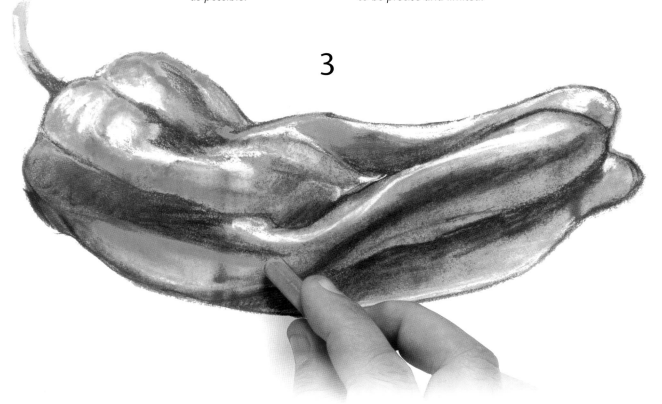

3

3 Use two tones of red and carmine chalk to reinforce the areas in light, while simultaneously incorporating the natural color of the pepper.

4 The shadow effect is obtained here by using various colors. The initial brown color should show through the red patches.

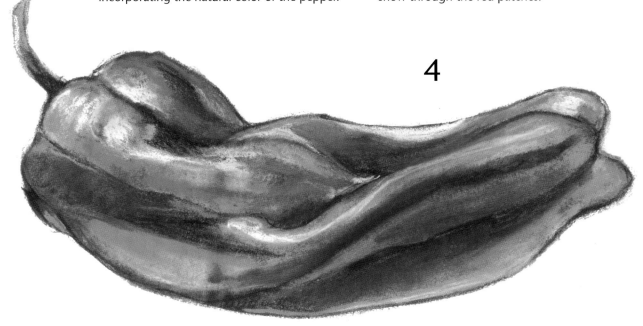

4

Shading with the Smudge Tool

This is another way to work in monochromatic light and shadow: by creating values with your smudge tool. Using your smudge stick over the intense patches of chalk will give you a graphic effect that cannot be achieved by smudging with your fingers or hand, due to the fact that you will be able to create dense shadows, or even intense lines, with the slanted or sharp tip of your smudge stick. The idea is to use your smudger as a drawing tool, rather than just a tool for smudging. In this section, we will be looking at how to use it to create soft tonal transitions and strong contrasts between areas of light and shadow.

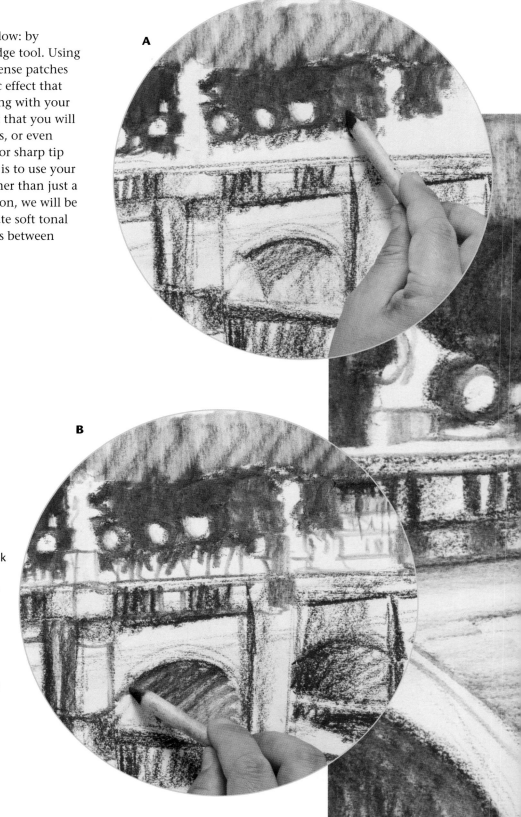

A Brown-colored chalk has an intense pigment that can be easily spread with your smudge tool. You can load the tip with pigment to cover the most densely shaded areas.

B Work on the edges in your drawing, trying to emphasize lines and even apply hatching with zigzag lines.

C You can achieve the most intense shadows by drawing thick chalk strokes that you can blend together with your smudge tool.

The end result is a nighttime scene of a bridge, incorporating an interesting interaction between light, shadow, and medium tones produced by blending the chalk pigment with your smudge stick.

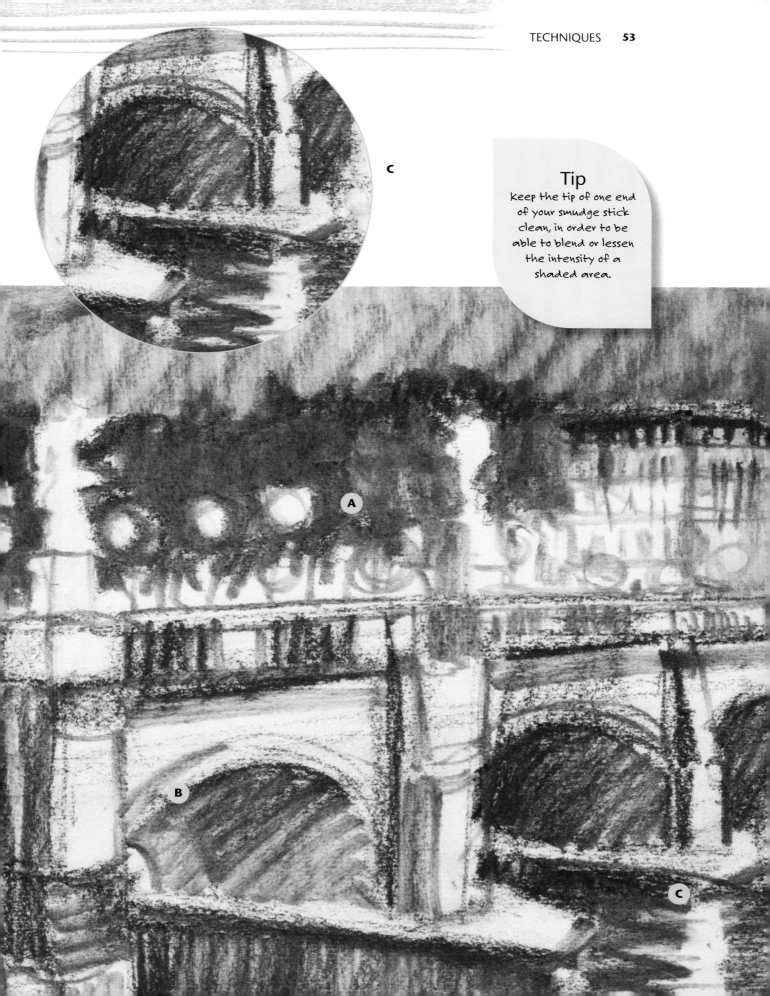

C

Tip
Keep the tip of one end of your smudge stick clean, in order to be able to blend or lessen the intensity of a shaded area.

Shading on Dark-Colored Paper

Shading on a dark-colored background will simultaneously develop light and shadow, which will give your subject a markedly three-dimensional appearance. You should develop this type of drawing with charcoal sticks or black-colored chalk; otherwise your strokes will not be visible. The same principle applies to shadows—they should be solid, intense, and opaque. You can always soften them with your smudge tool later on. In the last stage of your drawing, create the highlights with light-colored chalk, which will give your subject contrast, making it stand out from the dark background.

A Use a thin charcoal stick to draw the subject with a distinct linear stroke. You should pay special attention to the curvature of the hat's brim.

B Apply the first layers of shading, pressing down hard with your charcoal stick and clearly differentiating the shadows to make sure they contrast with the dark background.

C Blend the patches of charcoal with your fingers, establishing gradient fading that will better integrate the subject with the dark background.

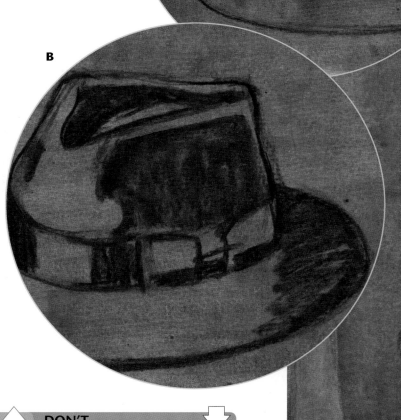

DO	DON'T
Press down hard with your charcoal sticks and softly with the chalk, which will allow the chalk to thoroughly color the paper.	Mix chalk and charcoal too much. The dark charcoal powder tends to give a very gray look to these mixes.

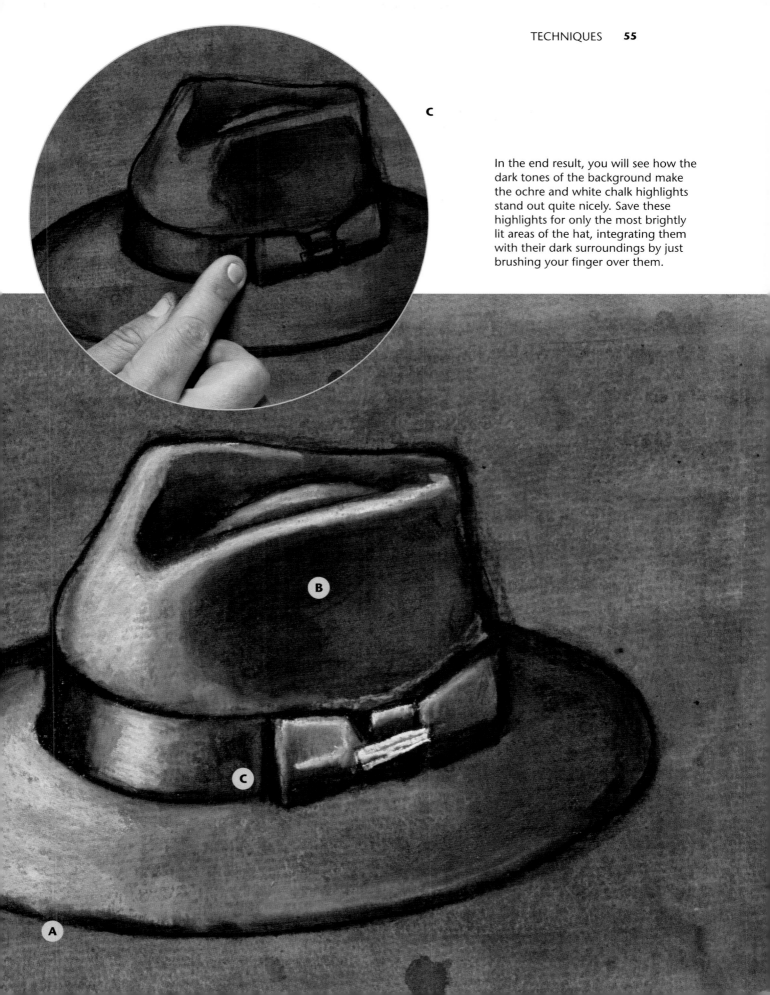

In the end result, you will see how the dark tones of the background make the ochre and white chalk highlights stand out quite nicely. Save these highlights for only the most brightly lit areas of the hat, integrating them with their dark surroundings by just brushing your finger over them.

Your subject will not always appear as an isolated object. Quite often, it interacts with its environment—and one of the most common ways it does this is by casting a shadow. A cast shadow can give your drawing a dramatic, theatrical look, as it represents a distorted image of the subject and places observers inside the context of the drawing, with all its imprecise appearances. It helps to establish your subject in the space surrounding it, and indicates the location of the source of light. Cast shadows aren't just simple black smudges, however—there are different types of them, depending on the effect that you want to create.

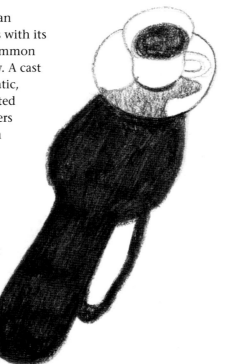

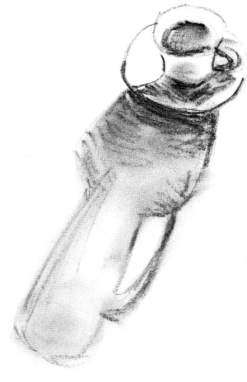

A solid cast shadow indicates that the light source is very strong, and highlights the solidity of your subject.

By lightly sketching a cast shadow, you can give it a more ethereal look and nicely complement a fragile, delicate subject.

Cast Shadows

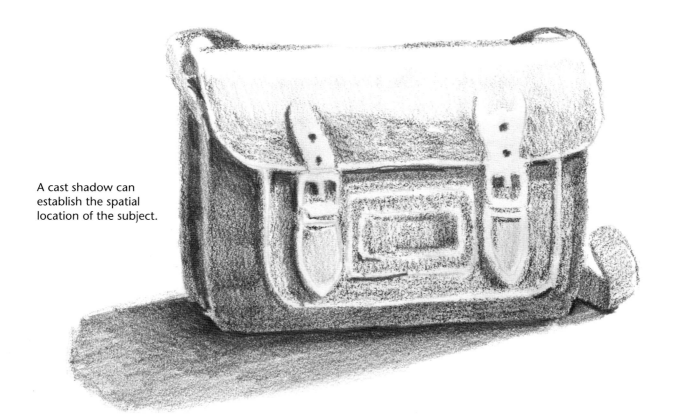

A cast shadow can establish the spatial location of the subject.

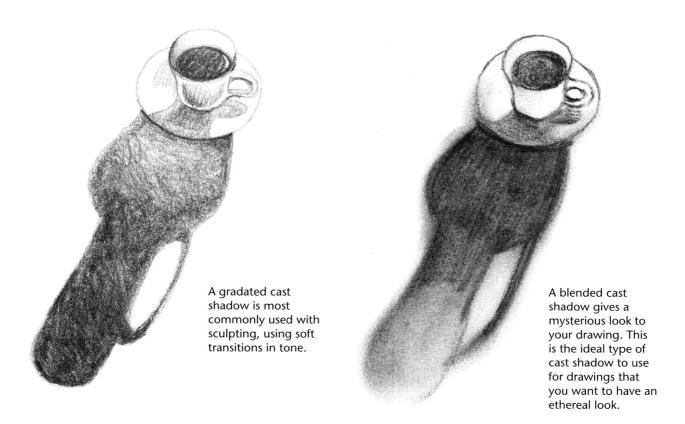

A gradated cast shadow is most commonly used with sculpting, using soft transitions in tone.

A blended cast shadow gives a mysterious look to your drawing. This is the ideal type of cast shadow to use for drawings that you want to have an ethereal look.

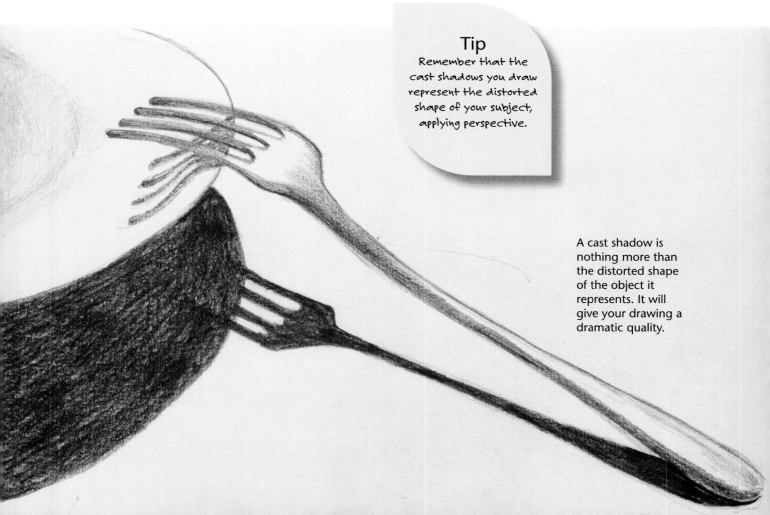

Tip
Remember that the cast shadows you draw represent the distorted shape of your subject, applying perspective.

A cast shadow is nothing more than the distorted shape of the object it represents. It will give your drawing a dramatic quality.

Shading on Coarse-Grained Paper

Along with your drawing tools, the paper you use is one of the most important elements in drawing. To a large degree, the end result will depend on the paper you choose. Coarse-grained paper will give a very particular look to your drawing, as the particles of pigment that stick to the raised parts of its granulated surface will appear as intense areas of color. With coarse-grained paper, shadows are more emphatic, lines are thicker, and it is harder to obtain a broad range of tones.

1

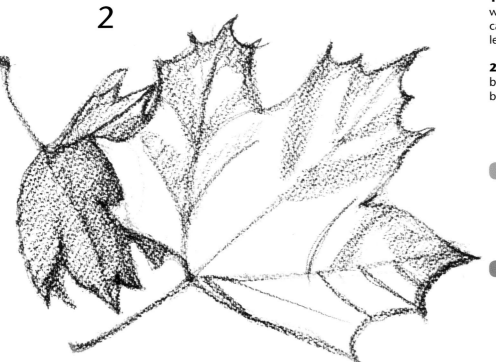

2

1 Draw the outline of this subject with red-colored chalk, trying to capture the irregular edges of the leaves.

2 Then go over the drawing with black-colored chalk. Your strokes will be thick and well defined.

DO

Avoid selecting complex subjects. It's best to pick subjects with well-defined shadows.

DON'T

Excessively saturate the grain of the paper by pressing down too hard with your chalk.

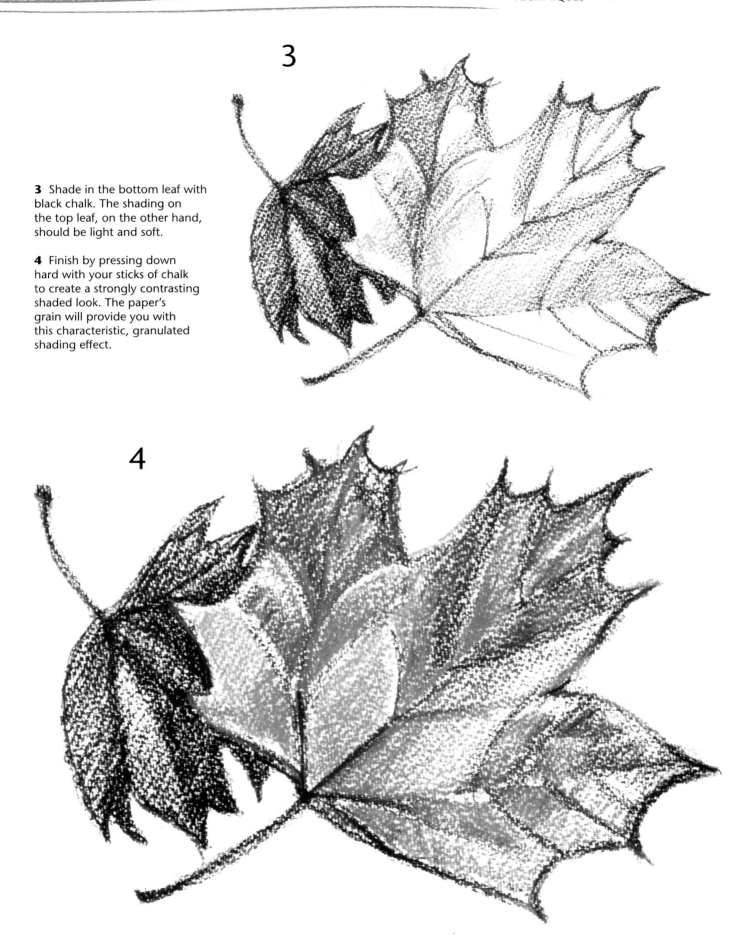

3

3 Shade in the bottom leaf with black chalk. The shading on the top leaf, on the other hand, should be light and soft.

4 Finish by pressing down hard with your sticks of chalk to create a strongly contrasting shaded look. The paper's grain will provide you with this characteristic, granulated shading effect.

4

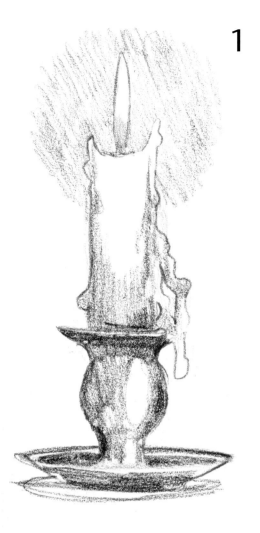

1

This style of shading suggests the shape of your subject by using an especially dim atmosphere, surrounded by a dark background. Light is almost entirely absent in this technique. The subject is enveloped in darkness, which is just barely penetrated by a small source of light—generally a small lamp or candle. This forces the artist to illuminate the scene based on the shadows, using very dark shading, with charcoal or chalk.

Engulfed in Shadow

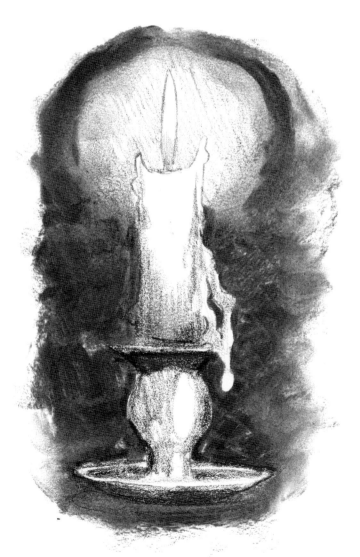

1 Use a thin charcoal stick to sketch out the shape of a lit candle on a small candlestick. The wax of the candle is enough to break up the symmetry of the composition.

2 Drag a small, inch-long piece of charcoal stick across the paper lengthwise, trying to darken the background but also maintaining the halo of light surrounding the candle's flame.

2

3

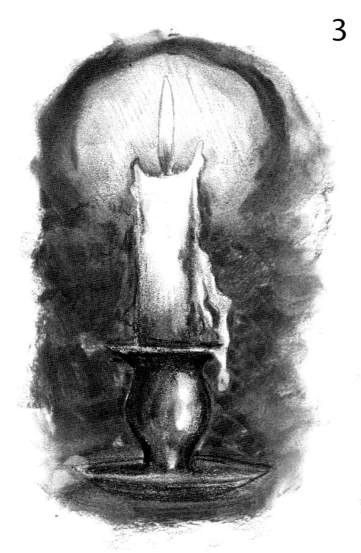

3 Use the tip of your charcoal stick to shade in the candlestick, blending the strokes with your fingertips. Leave a small area blank to indicate the shiny highlight on its metallic surface.

4

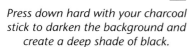

DO ⬆

Press down hard with your charcoal stick to darken the background and create a deep shade of black.

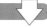

DON'T ⬇

Work with sweaty or greasy hands, since this will create unexpected stains when smudging your charcoal.

4 Finish the drawing with compressed charcoal, which will provide you with deeper shades of black in the background and at the base of the candle. This is one of the few cases in which the source of light is actually depicted in the drawing.

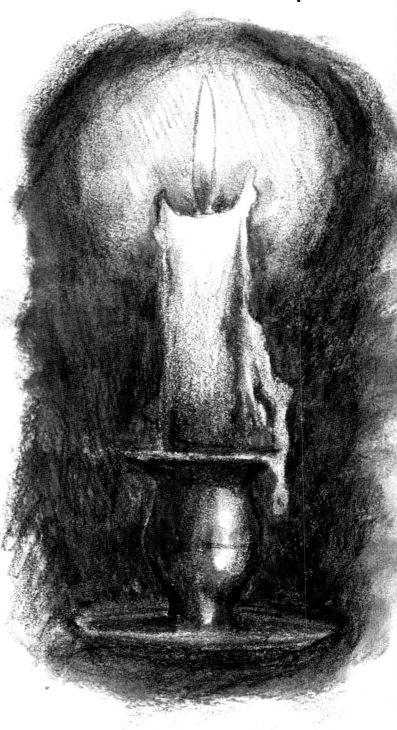

Shading with Ink Wash

Up to this point, we have seen how to achieve the shading effect with dry techniques. However, there are other drawing techniques out there as well—including ink drawing—which allow you to create very contrasting, well-structured shading. We will begin with the ink wash technique, a very simple method that consists of loading a wet brush with color and depositing it on the surface, with varying amounts of water, to create brighter tones in the well-lit areas of your drawing and denser tones in the darker areas. The tone of the shadows will depend entirely on the amount of water you add to the ink.

1

1 Begin shading by applying a glaze of blue ink heavily diluted in water.

2 When the initial wash has dried, apply a second layer on top of it to support the medium tones. Leave the brightest areas blank, allowing the initial wash to show through.

2

3 Your subject now shows a varied interaction between lights and reflections, achieved with nothing but different shades of blue ink.

3

4

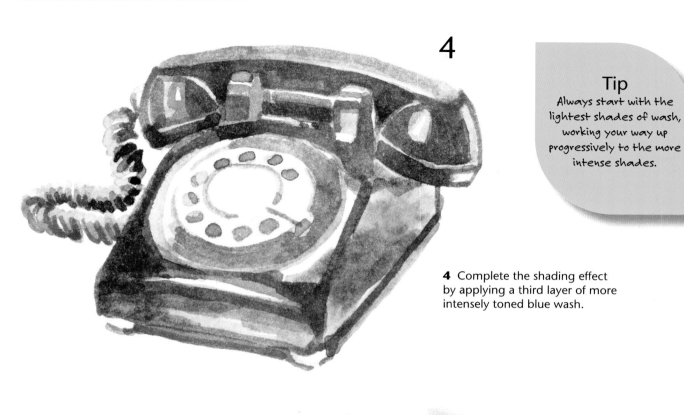

4 Complete the shading effect by applying a third layer of more intensely toned blue wash.

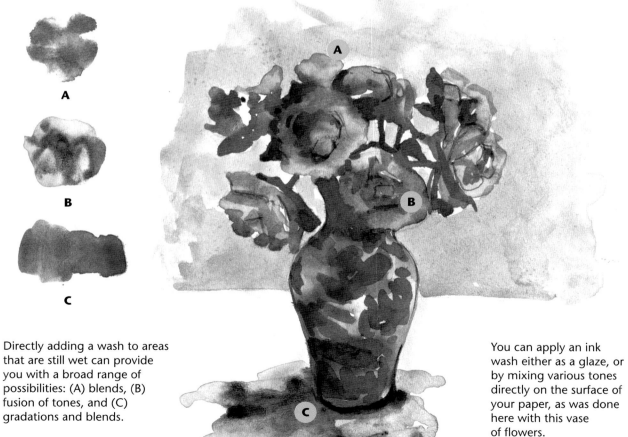

Directly adding a wash to areas that are still wet can provide you with a broad range of possibilities: (A) blends, (B) fusion of tones, and (C) gradations and blends.

You can apply an ink wash either as a glaze, or by mixing various tones directly on the surface of your paper, as was done here with this vase of flowers.

Both a metallic nib pen as well as a reed pen will provide you with clean, well-defined strokes when working with ink. You can use them to establish the outline and form of your subject, and to create a shadow effect, establishing the depth of the subject. When you need to produce different tones of shading with just one color, without using ink washes, the trick is to use different types of strokes that will create different shades of gray, of varying intensity. More heavily concentrated overlapping lines will give you more intense areas of shadow, while more widely spaced lines will create lighter shades of gray.

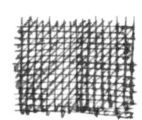

A

Shading with Hatching Patterns in Ink

B

By changing the direction of strokes, you can distinguish or differentiate two different tonal areas from each other.

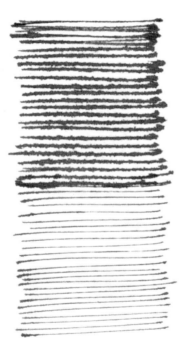

A A perpendicular cross-hatching pattern covers the background of this drawing.

B A cross-hatching pattern with diagonal lines intensifies the shadows surrounding the flower.

C The upper petals of the flower feature a fading hatching pattern.

D Angled cross-hatching is used to depict the shadows at the flower's base.

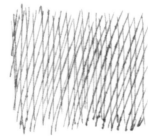

C

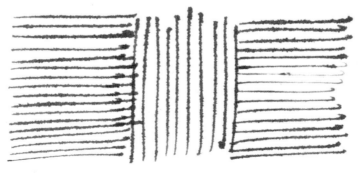

The intensity of the shadow will depend on the thickness of the lines used in the hatching, as well as the space between them.

D

Tip
Use different types of metallic tips to guarantee a broader variety of strokes.

By creating different types of hatching patterns, using a metallic nib pen with India ink, you will be able to create interesting light and shadow effects.

Subjects

In the first section of this book, we analyzed and studied basic methods for effectively creating light and shadow, going over all the possible variations. In this second section, we will continue to study these techniques. However, we will apply them to the most common subjects of artistic drawing: primarily landscapes, still life, and human figures.

Any subject that features contrasts between light and shadow can be drawn using several of the shading techniques we have already discussed. We invite you to practice these techniques on the subjects presented in this section, using the recommended media for each subject in order to get the most out of each exercise.

Origami with Graphite Pencils

We will begin with the shading of a very simple subject: a paper bird, created with the paper-folding technique known as origami. This very angular subject will allow you to easily establish each surface of the object, applying simple shading with 2B and 4B graphite pencils. By combining flat shading and gradated areas, you will be able to give it the perfect amount of volume. For this exercise, use fine-grained, glossy paper.

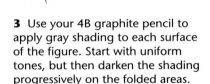

1 First, use your 2B graphite pencil to establish the outline of the subject with linear strokes. The geometric character of this subject should be easy to draw.

2 Apply the initial shading with the tilted edge of the pencil tip, shading the inner part of the folded areas, applying broad areas of gradation to the largest surfaces.

3 Use your 4B graphite pencil to apply gray shading to each surface of the figure. Start with uniform tones, but then darken the shading progressively on the folded areas.

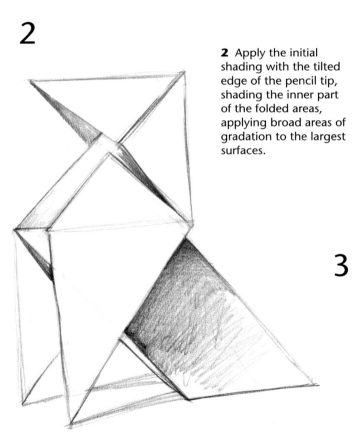

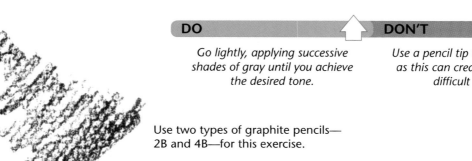

Use two types of graphite pencils— 2B and 4B—for this exercise.

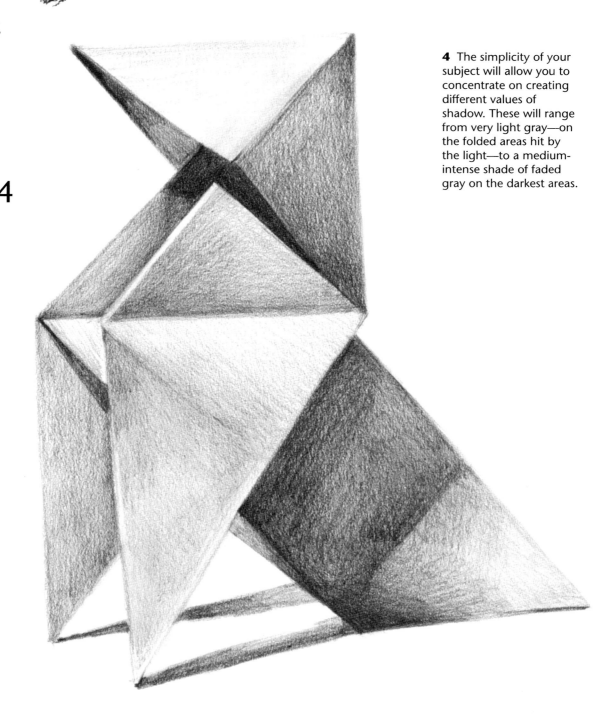

4

4 The simplicity of your subject will allow you to concentrate on creating different values of shadow. These will range from very light gray—on the folded areas hit by the light—to a medium-intense shade of faded gray on the darkest areas.

Bottle with Graphite Watercolor Pencils

A variety of watercolor wood-encased and woodless graphite pencils are available on the market. These will allow you to create pieces with soft gradation, produced by diluting the graphite in water. The process is quite simple: develop the subject progressively, with successive layers of shading; then blend these gray areas with a wash, applied with a soft-bristled watercolor brush. Use fine-grained watercolor paper for this technique.

A Progressively shade your drawing with graphite, pressing down lightly to avoid leaving any permanent strokes. You will then blend the gray areas with a water-loaded brush.

B Use a 6B woodless graphite pencil to intensify the values of the cast shadow and the inside of the bottle.

C Medium-toned shading on the bottle will become more intense when dissolved with water. Stroke downward with the brush, and avoid applying more than two brushstrokes to the same spot.

D Shading done with graphite can be diluted with water, which will create a shading effect with soft gradation. Meanwhile, leave the brightest areas blank to depict the reflections of light on the glass surface.

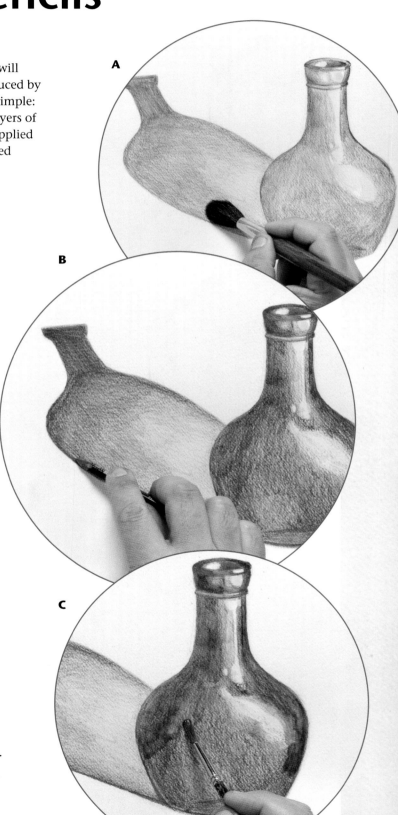

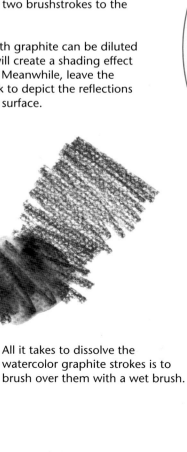

All it takes to dissolve the watercolor graphite strokes is to brush over them with a wet brush.

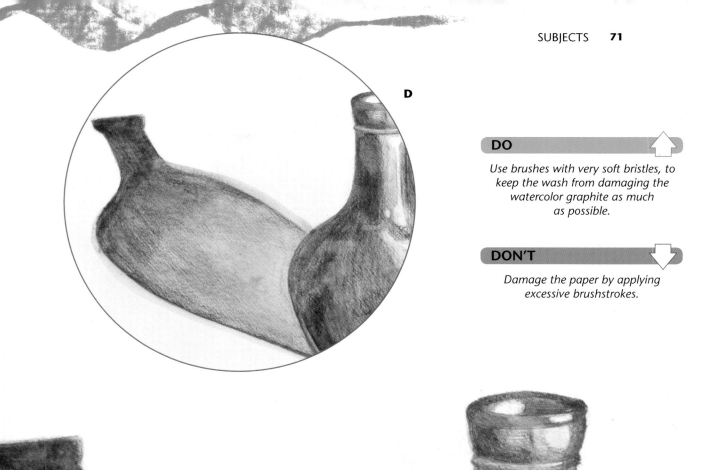

D

DO ⬆

Use brushes with very soft bristles, to keep the wash from damaging the watercolor graphite as much as possible.

DON'T ⬇

Damage the paper by applying excessive brushstrokes.

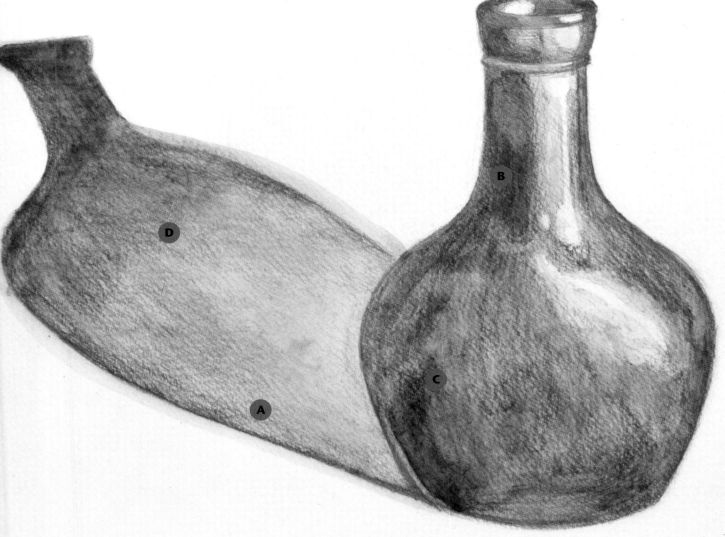

In this exercise, we will practice controlling gradations and the sculpting effect to explain how to distribute light over a smooth-surfaced subject. The goal of this exercise is to depict a sofa with a light-toned shading technique; in other words, you will use light shading to depict a subject in very bright light. You will use your 4B woodless graphite pencil to work on this technique, beginning with the initial—nearly imperceptible—shadows and lines, and working up to a convincing, three-dimensional drawing of the subject.

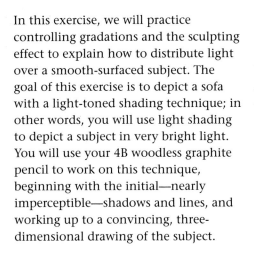

1

Gradations with Graphite Pencils

1 Before beginning any drawing, it's a good idea to practice a few sketches on a blank sheet of paper to familiarize yourself with your tools.

2 The initial sketch is completely geometric. Try to create the basic shape of the sofa with very few lines, as if you were sketching out its structural framework. Use very light strokes.

2

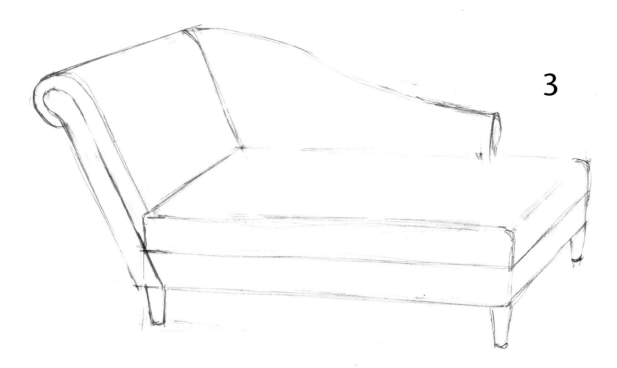

3

3 The second stage involves transforming the geometric structure of the sofa. Be careful when drawing the outline of the sofa, paying special attention to the inclination and curvature of its back.

4 Once you have consolidated the line drawing, you can start shading it in with the woodless graphite pencil. The shadows should be faded and very light and are created by pressing down very softly with the pencil, barely brushing it against the paper.

Tip
Start with exercises involving very light shading, which you should do with an HB or 2B pencil.

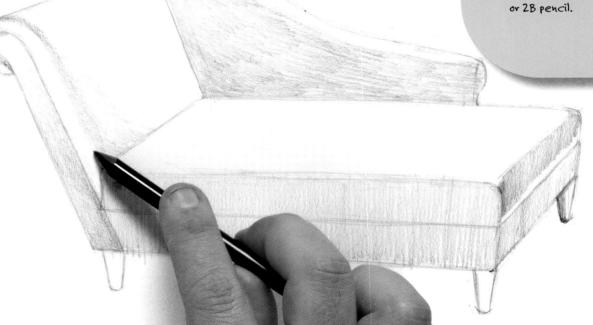

4

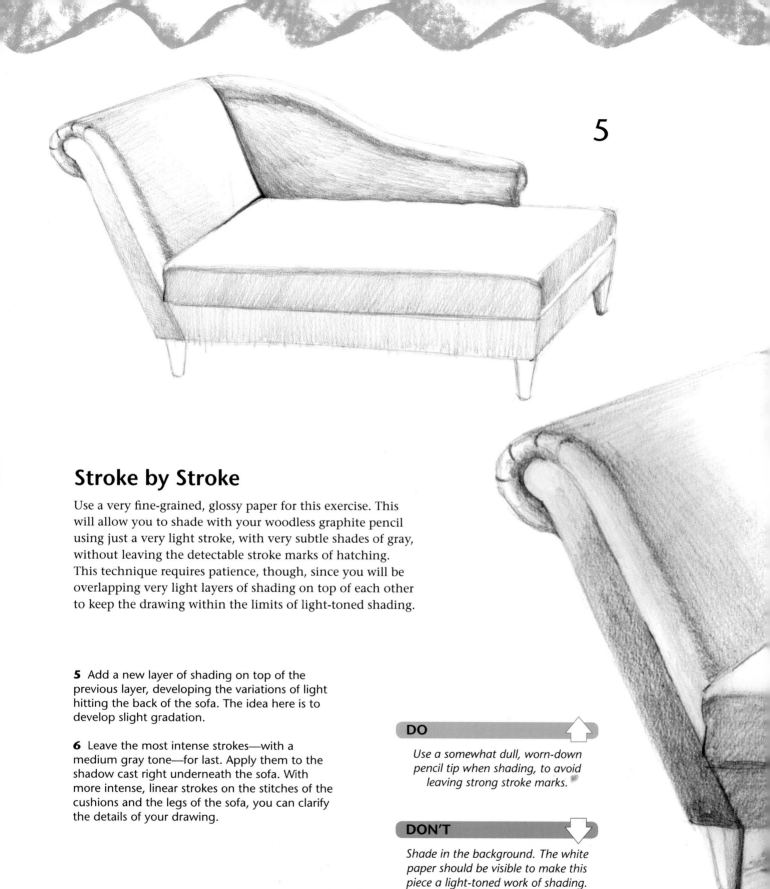

Stroke by Stroke

Use a very fine-grained, glossy paper for this exercise. This will allow you to shade with your woodless graphite pencil using just a very light stroke, with very subtle shades of gray, without leaving the detectable stroke marks of hatching. This technique requires patience, though, since you will be overlapping very light layers of shading on top of each other to keep the drawing within the limits of light-toned shading.

5 Add a new layer of shading on top of the previous layer, developing the variations of light hitting the back of the sofa. The idea here is to develop slight gradation.

6 Leave the most intense strokes—with a medium gray tone—for last. Apply them to the shadow cast right underneath the sofa. With more intense, linear strokes on the stitches of the cushions and the legs of the sofa, you can clarify the details of your drawing.

DO

Use a somewhat dull, worn-down pencil tip when shading, to avoid leaving strong stroke marks.

DON'T

Shade in the background. The white paper should be visible to make this piece a light-toned work of shading.

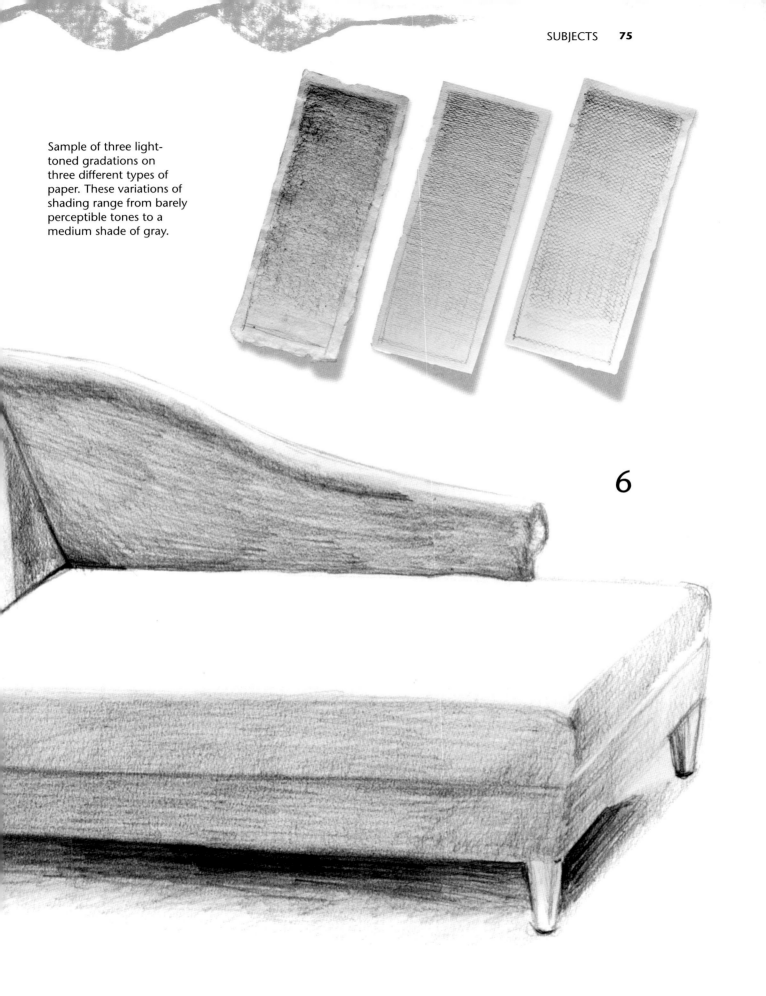

Sample of three light-toned gradations on three different types of paper. These variations of shading range from barely perceptible tones to a medium shade of gray.

6

1

Landscape Shaded with Hatching Patterns

1 Before you start, it's a good idea to test out different types of strokes on a sheet of scratch paper to make sure your pencil has the right degree of sharpness.

When using hatching patterns in shading, the varying intensities of shadow are determined by a series of strokes that are grouped closer together or further apart. The distance between these lines—and their thickness—determines the intensity of your shading. When you change the direction of the lines as well, you'll be able to create a textured depiction of a subject, which will give your drawing an added visual richness. In this exercise, we will be alternating between charcoal sticks, pressed charcoal pencils, and black chalk.

2

2 Make the initial sketch of the basic outlines of your landscape—in this case, the curvature of the mountains—with charcoal.

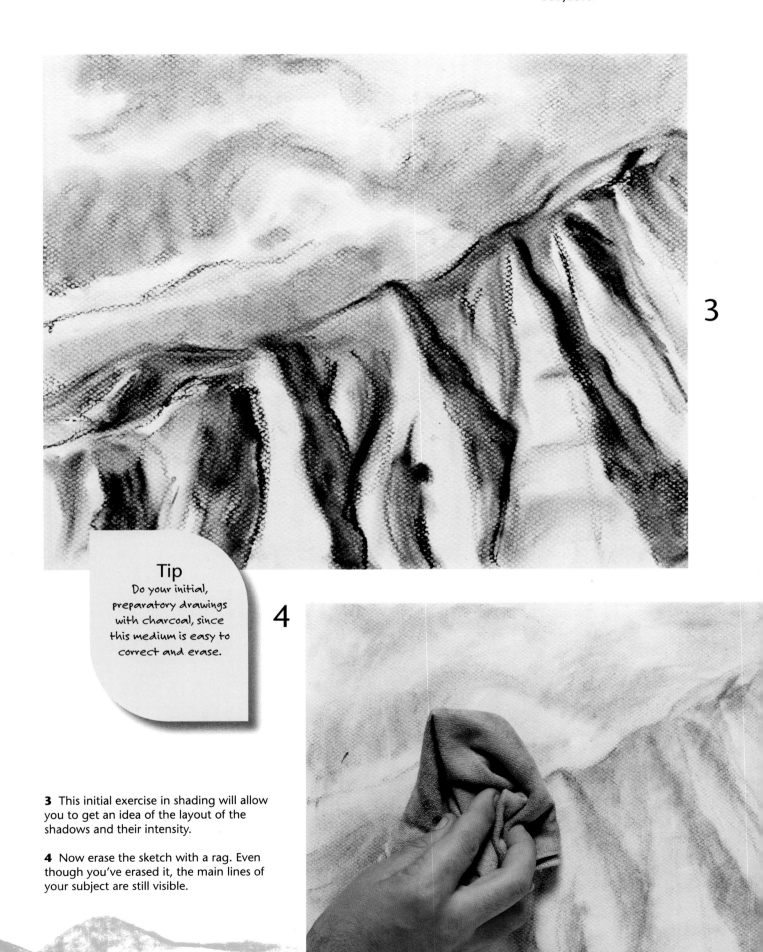

3

Tip
Do your initial, preparatory drawings with charcoal, since this medium is easy to correct and erase.

4

3 This initial exercise in shading will allow you to get an idea of the layout of the shadows and their intensity.

4 Now erase the sketch with a rag. Even though you've erased it, the main lines of your subject are still visible.

Developing Smudges with Hatching

Based on the initial drawing done with charcoal, you will now develop the same shading effect with lines and hatching patterns, giving a sense of volume to the terrain of the mountains.

5

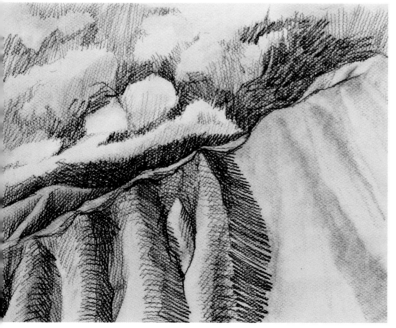
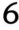

5 Use a well-sharpened black chalk pencil to draw hatching on the gullies of the mountainside, which will help to establish their contour.

6 In the sky, you will draw hatching patterns, with somewhat chaotic strokes, that surround the blank areas of the paper representing the clouds.

7 Changing the direction of your hatching—as well as the variation and intensity of the lines—is of fundamental importance for describing the undulation of the ground.

8 The shadows in the sky are developed with a series of intersecting lines, in varying directions, while the shadows on the mountainside are described with enveloping lines.

6

8

7

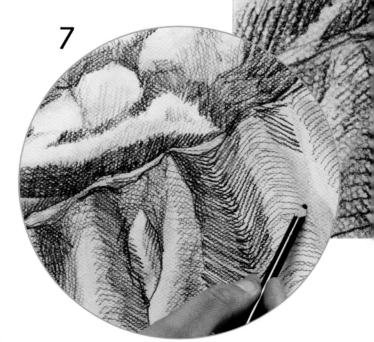

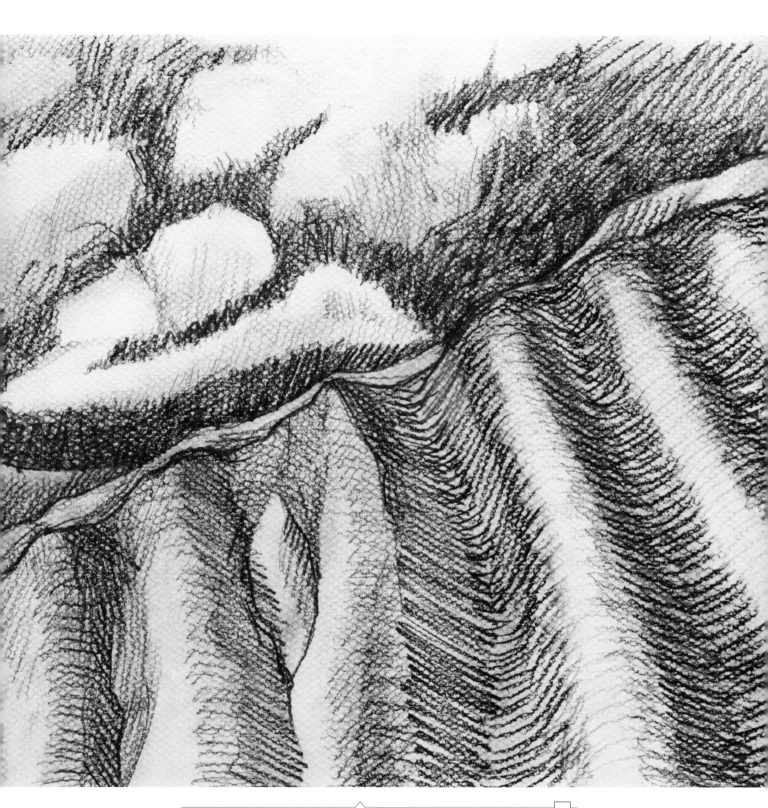

DO

Vary how hard you press down with your pencil, depending on the intensity of the shadow.

DON'T

Erase strokes with a conventional eraser, since you might end up smudging the area instead of clearing it.

Backlit Landscape with Chalk

Backlighting is a common technique for developing contrasted shading, characterized by strong lighting just behind the subject. One of the effects of backlighting is that it emphasizes the outline of the main subjects in the image—in this case, the elements of the landscape, which are clear-cut and silhouetted by contrast. The effect makes it look like a background of light outlines the shape of the objects, providing the greatest possible contrast between light and shadow. This exercise should be done with dark brown chalk, on fine-grained paper.

Drawings done against a sunset have an extra dose of natural and fresh lighting, with the added benefit of not irritating the eyes of the observer. This technique takes advantage of the fact that humans are familiar with the effect of background sun in different situations throughout our day-to-day life.

A The brown chalk is made more dense and dark by smudging it, which helps fill the pores of the paper.

B A cotton rag will allow you to decrease the intensity of a shaded area by trapping the particles of pigment between the fibers of the paper, which will allow you to make the background color brighter.

C The highlights that are reflected on the water's surface are made with a kneaded eraser molded into a wedge shape.

DO ⬆

Include gradations in the water and sky, as these will create a halo of mystery.

DON'T ⬇

Smudge the edges of the drawing's elements, as these should appear properly outlined.

A

B

C

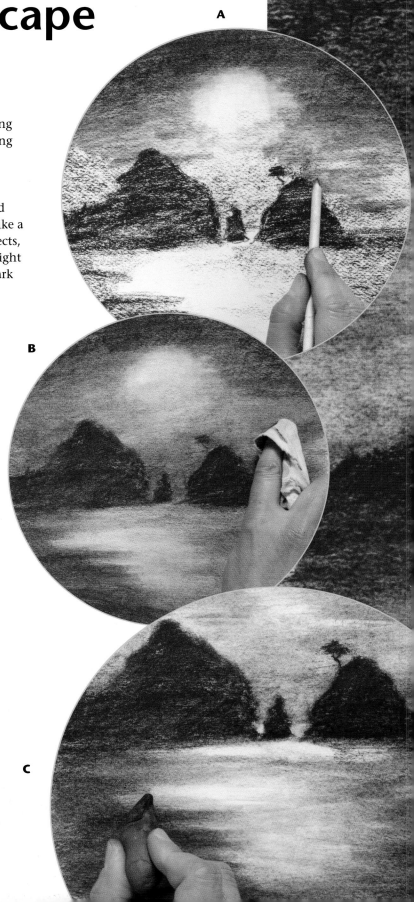

Cup in Light & Shadow

When working with charcoal, the shading effect is quite intense, and will give your drawings an almost paint-like quality. In addition, it creates a sense of atmosphere, light, and character. Thanks to the contrast provided by the shading, artists are able to establish and highlight the shape of their subjects, without having to outline them with a dark line, which often limits and stiffens the shape. All it takes, with this technique, is to juxtapose the light areas against other, darker areas. The following subject is quite simple, and will allow you to develop the charcoal shading technique before you face tougher obstacles in the following pages.

A You will work with just three tones: the white of the paper, intense black, and a medium shade of gray, which you will develop by blending the charcoal with your fingers.

B You won't need to draw lines around your subjects; rather, all you need to do is establish their outlines with dark shadows that create the maximum contrast against the brightest areas of the drawing.

C Go over the brightest areas with your kneaded eraser. The highlights are of fundamental importance for establishing the volume of the subject.

A

B

Tip
Let inner shadows blend with other shadows in certain parts of your drawing. This will keep the elements of the still life from being too strictly defined.

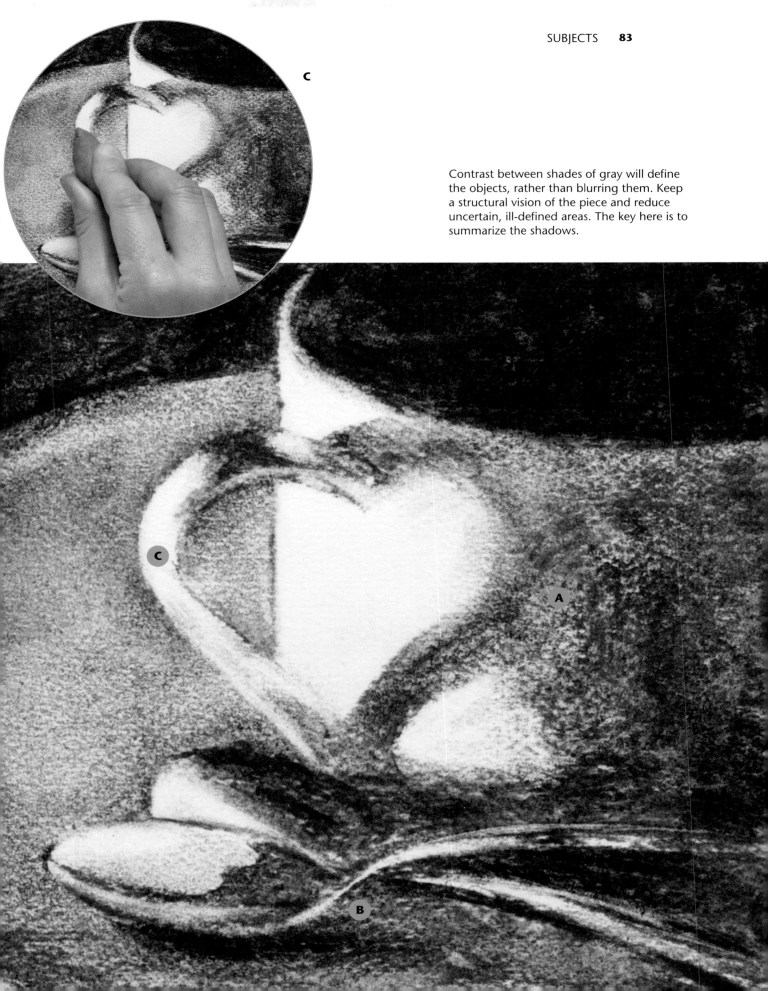

Contrast between shades of gray will define the objects, rather than blurring them. Keep a structural vision of the piece and reduce uncertain, ill-defined areas. The key here is to summarize the shadows.

Still Life with Charcoal on Textured Paper

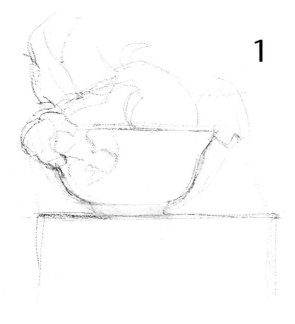

1

One of the most important characteristics of charcoal is how easily it can adapt to the texture and grain of the paper's surface. For this reason, when working on a very textured surface, the strokes created by a charcoal stick will provide you with a granulated effect that will make the darkest areas of shadow more interesting. In this exercise, you will develop a maximum shading effect on textured paper. This means that you will be creating strong contrasts between the lit areas of this figure and the background, saturating the pores of the paper's surface as much as possible.

1 Start the drawing on granulated paper. Your charcoal strokes should be soft, since they will be harder to erase.

2 Shade in your drawing in blocks, dragging the charcoal stick lengthwise across the paper. The dark value of the background will make the lit composition stand out.

3 Soften the shading by rubbing the paper's surface with a flat smudge stick. In other words, press it against its side to keep the tip from interfering.

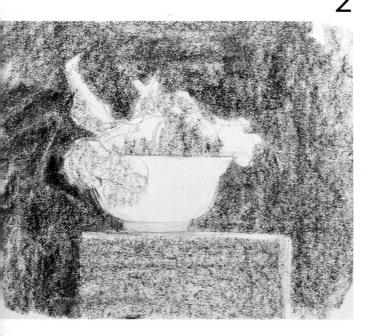

2

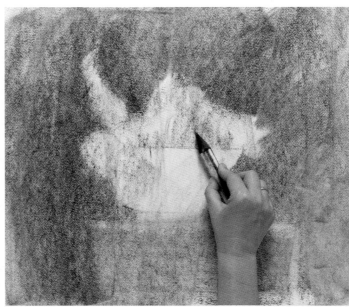

3

4

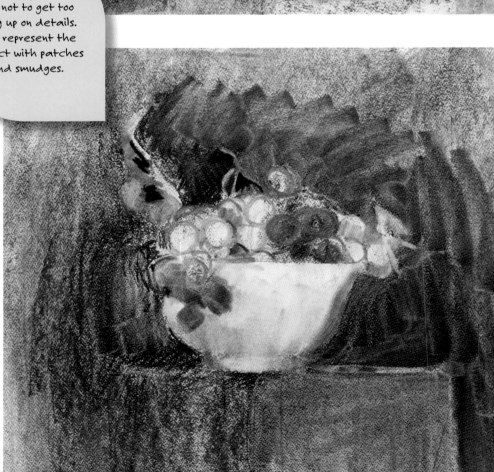

Working with a flat charcoal stick will allow you to create a shadow that is not entirely opaque, marking only the surface of the paper's grain.

Tip
Try not to get too hung up on details. Just represent the subject with patches and smudges.

4 Another light layer of shading with your flat charcoal stick will establish the values of the background and contrast some of the shapes in the fruit bowl, without specifying their details.

5 With coarse-grained paper, it's important that the values contrast with each other. If the differences between them are too subtle, it will weaken the end effect.

5

Saturating the Shading

To emphasize the shading effect, saturate the shadows. Load the paper's surface with extra pigment to fill in its pores and obtain the maximum contrast between the illuminated fruit bowl and the darkest parts of the background.

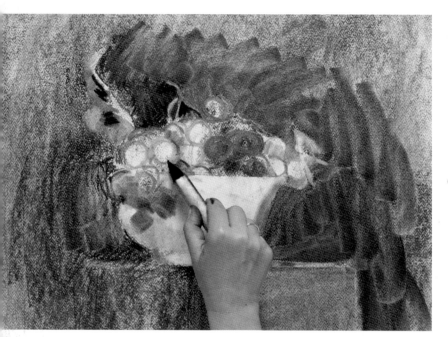

To saturate the paper's grain, press down hard with a blunt tip to produce a very intense black.

6

6 With the tip of the smudge stick, draw the shape of the grapes. You will be smudging with the charcoal dust, so the strokes will look weathered, but sufficiently visible.

7 You will create the most intense contrasts by drawing the outline of the subject with the tip of your charcoal stick, seeking to achieve maximum density.

8 The light and shadow effect on the bunches of grapes is the result of sculpting the shadows with the smudge stick, and opening up some white areas with your kneaded eraser.

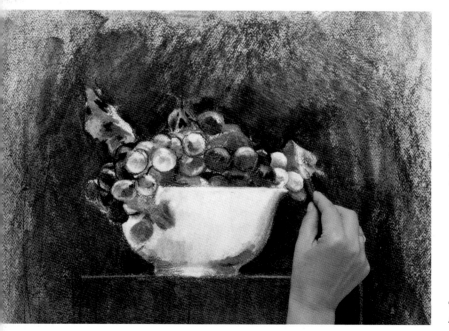

7

DO	DON'T
Intensify the black only around the edges of the object. Leave the rest of the paper with sketched, unfinished shading.	*Accidentally smudge the white areas of the fruit bowl with your hand.*

8

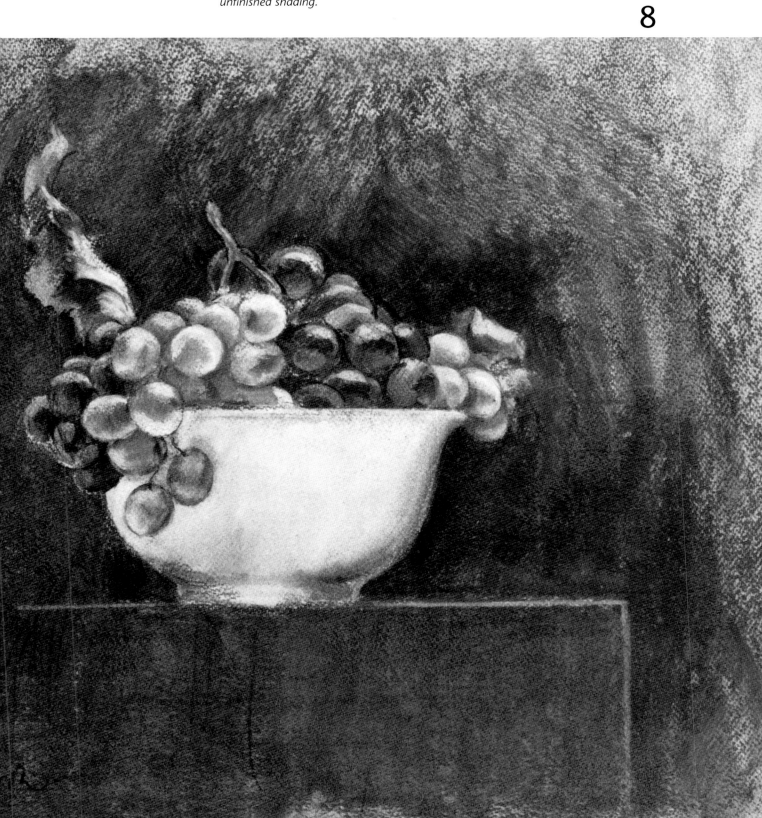

Drawing of Building with Graphite Pencils

A contemporary building, with some of its sides facing away from the light, appears as a collection of very different surfaces that are illuminated in very different ways, all interacting with each other, casting shadows over and reflecting off of each other. To develop the shading of this building without getting disoriented by all the subtle details, it's a good idea to simplify. Define the basic flat surfaces and search for the edges and contrasts that naturally divide the lit areas from the shaded ones. This exercise uses different types of graphite pencils on glossy paper.

1 The initial layout requires a special degree of attention, since you will need to establish the shape of the building with perspective, using diagonal lines with vanishing points.

1

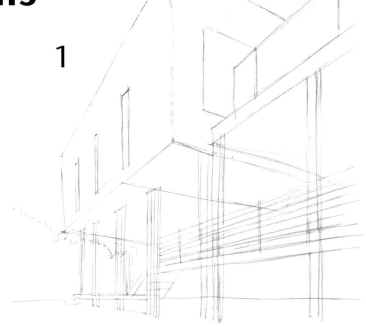

2

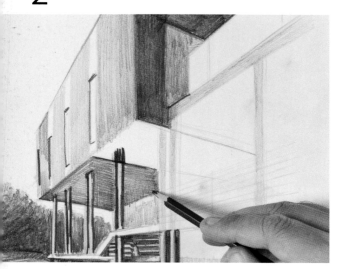

3

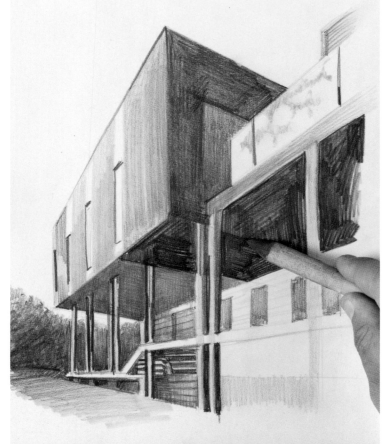

2 Use your 4B graphite pencil to differentiate each one of the building's surfaces with a different shade of gray.

3 Your smudge stick will help you to level out the shadows and make them more dense, at the same time as you reduce the traces of your pencil strokes.

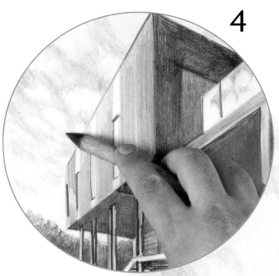

4

4 Use the tip of your smudge stick with graphite to suggest the clouds in the sky and the reflections on the building's glass surfaces.

Tip
Don't feel that you need to systematically fade each surface. The shading is based on a simple distribution among the surfaces.

5 To make sure the shading of a building is effective, it's a good idea to reinforce the edges and corners of the surfaces. This will make the areas of light and shadow clearly distinguishable from one another.

5

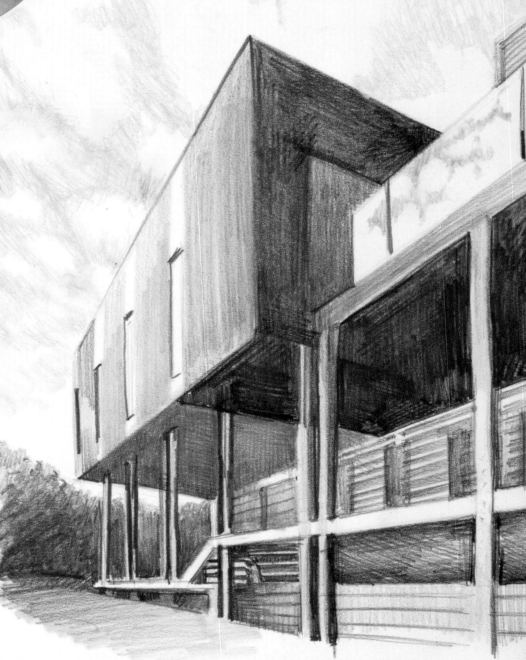

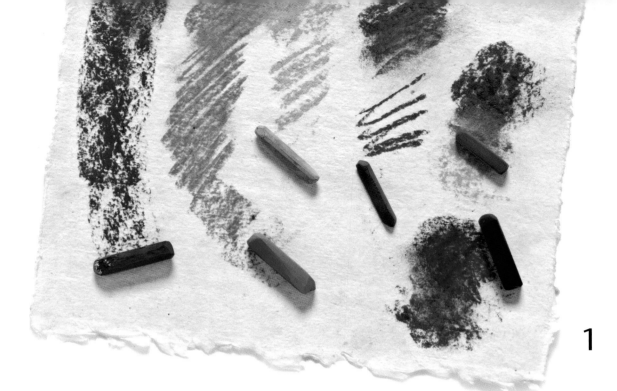

1

Indoor Scene in Lateral Light with Blue Chalk

2

Indoor scenes are not a very common theme for many artists, but they can make for great subjects—especially when the weather turns nasty. While you may find some indoor scenes to look boring or ordinary, you might be surprised to find the interesting interaction between light and shadow they can offer, especially when the light enters through a small opening and creates a series of reflected lights and cast shadows. In this exercise, you will be using blue chalk.

1 Before you begin to draw, pick out two shades of blue that are best suited for the job. We have chosen a royal blue and a medium shade of ultramarine.

2 When drawing an indoor scene, the first thing to do is lay out the limits of the space—the lines defining the walls and the arches of the ceiling.

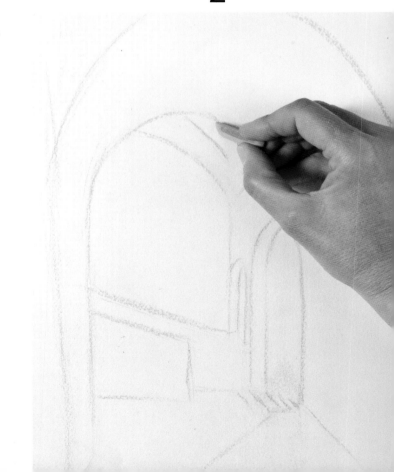

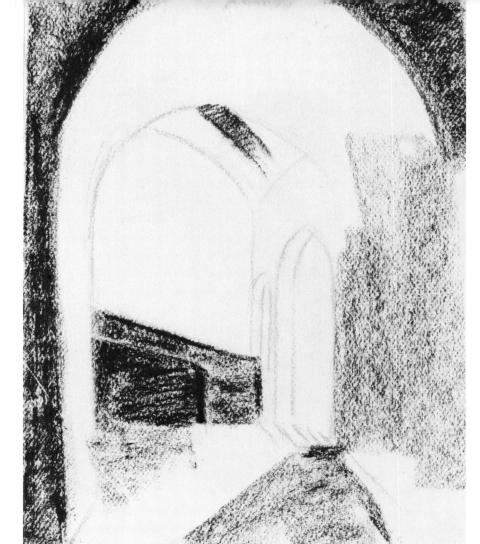

3

3 Practice the initial shading by dragging the flat ultramarine chalk bar across the page, obtaining an initial color synthesis of the combined elements.

4 Cover the interior of the arches with royal blue and blend it with the ultramarine shading, rubbing it with your finger. This mix will produce faded areas.

Tip
Progressively smudge the remains of chalk dust as you apply it.

4

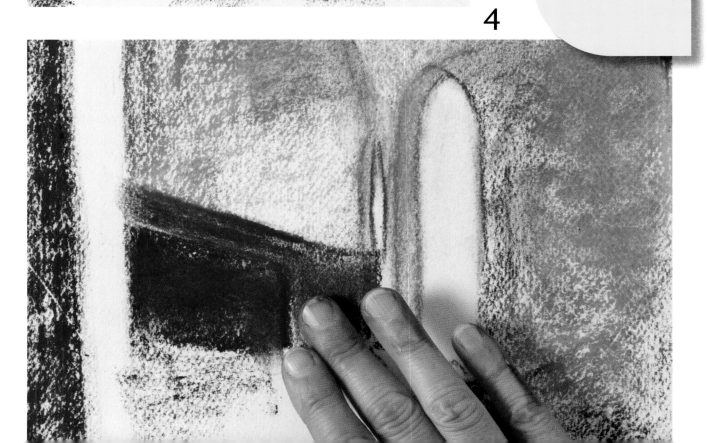

Light as the Center of Attention

An indoor scene will acquire a new spatial dimension, become more interesting, and achieve greater depth when it includes an open door in the background that lets light in. In addition to being the center of attention in the drawing, this door will establish the diagonal lines of cast shadows.

5 The lines of your initial drawing will nearly disappear at this point, making way for the areas of light and shadow for contrast.

5

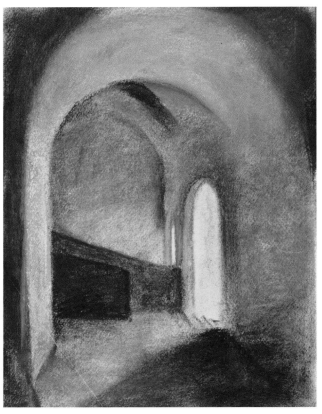

6

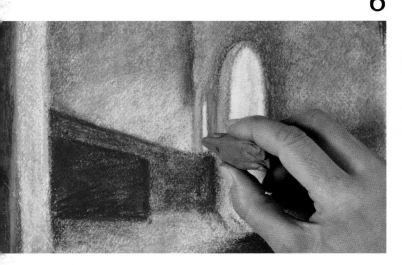

6 Accentuate the shading at the base of the walls, the arches, and around the door. Use your kneaded eraser to establish the outlines of light.

7 Use the ultramarine blue chalk to progressively darken the drawing, paying attention to details and nuances.

8 The application of blue chalk will emphasize the direction of light. It's important that your strokes blend naturally with each other, to make sure the border between light and shadow never appears to have a clear dividing line.

7

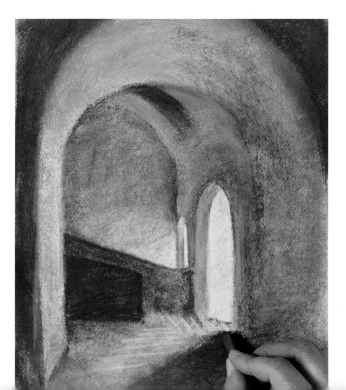

DO ⬆

As much as possible, draw with the flat edge of the colored chalk rather than its tip.

DON'T ⬇

Draw lines that are too clearly marked, since they will be difficult to integrate into the general shading scheme later on.

8

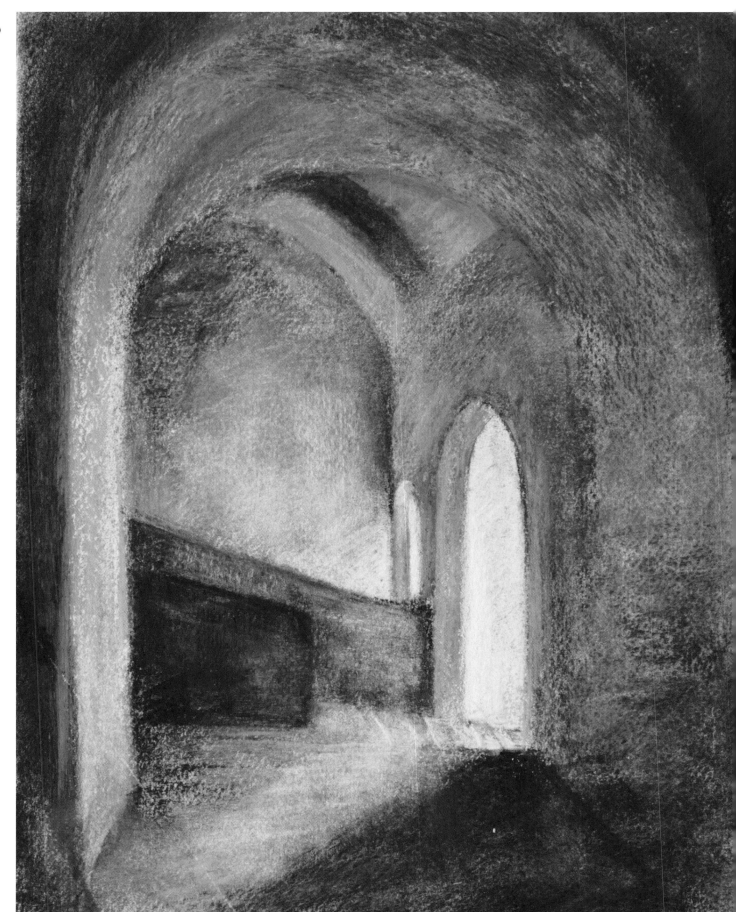

Nighttime Scene with Compressed Charcoal Pencils

Compressed charcoal pencils are extremely useful for small-format drawings. You need to use them with care, because they produce much stronger marks than charcoal sticks do. It's a good idea to proceed by creating shadows based on small strokes of varying intensity, that you will then blend with the smudge stick. For the darkest parts of the drawing, you can create very deep shades of black if you press down harder on the paper. Let's look at how you can create the light and shadow effect in a nighttime scene, using a combination of various compressed charcoal pencils.

1 With a hard charcoal pencil, sketch out the lines indicating the building, and suggest a shaded tree that will appear on the right side of the page.

2 The initial shading should also be very soft. Make sure your strokes are barely visible and will disappear completely when smudged with your hand.

1

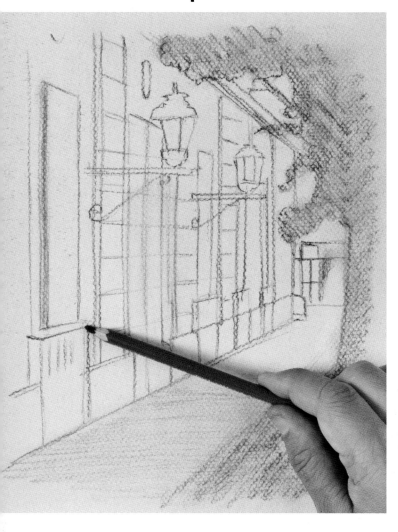

2

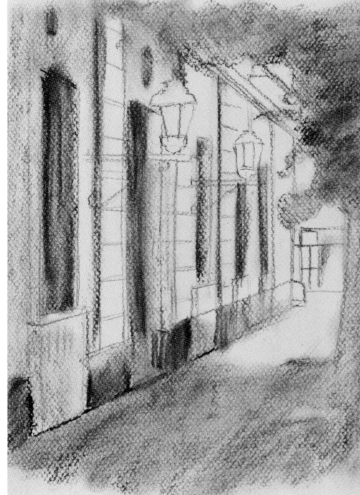

3 Leave the paper blank in the area around the lamps, and darken the doors and windows of the building.

You should shade softly with your compressed charcoal pencil, as it produces much stronger marks than the charcoal sticks do.

3

Tip
Don't be in a hurry to darken your drawing. The shading should be done in a slow, progressive way.

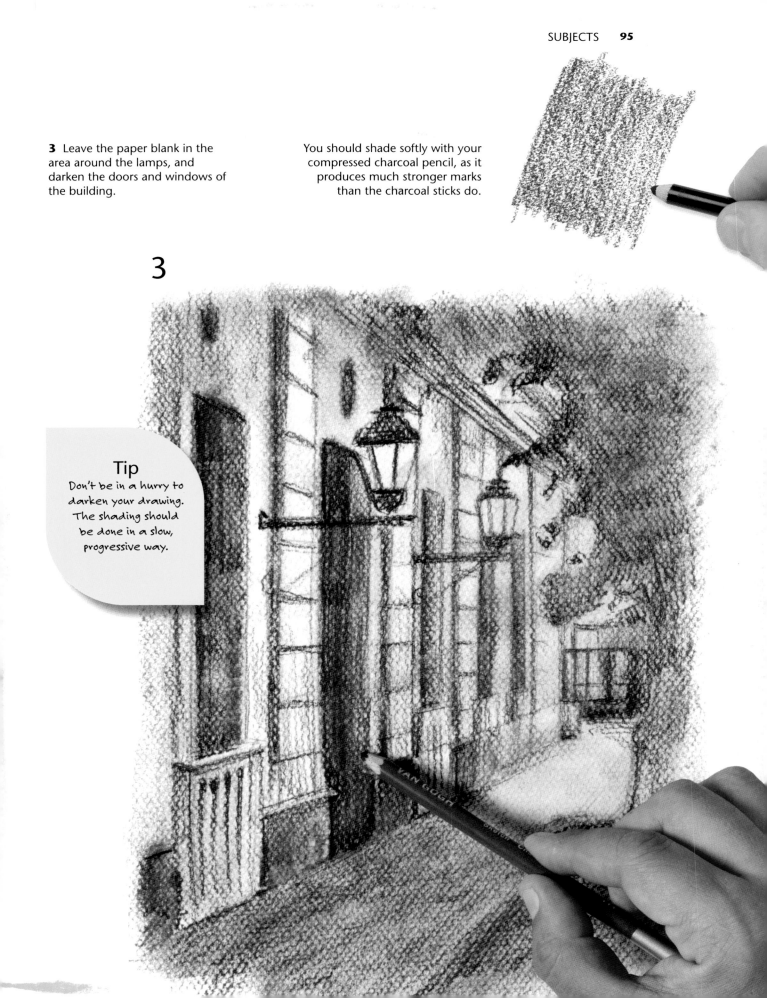

The Light on the Building's Surface

To create this nighttime scene, it's important to take into consideration the sources of light that illuminate it—in this case, the two lamps on the front of the building. You will need to create a halo of light around these elements, recreating the effect of the light radiating from them.

4 Do the shading in a progressive, cumulative way. In other words, you should overlap shades of soft gray on top of one another, making them progressively darker.

5 Work on the last phase of shading with your smudge stick, which will tend to darken the strokes made with the compressed charcoal pencil.

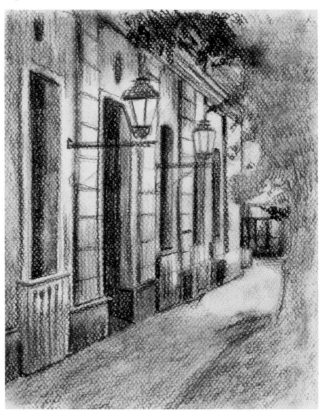

5

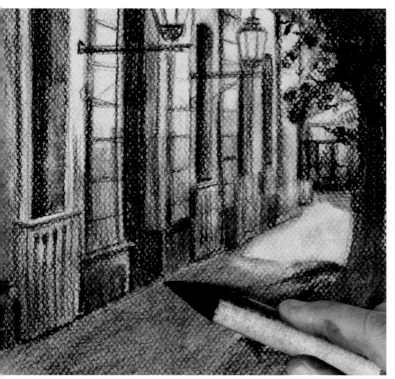

6 When you have finished establishing values, recover the most brightly lit areas by erasing the space around the lamps with your kneaded eraser.

7 To achieve the effect of light radiating from its source, leave a blank area of light around the lamps, which will produce a strong contrast with the silhouette of the tree in the foreground.

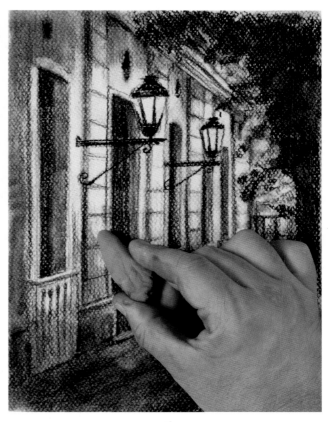

6

*Grasp the charcoal pencil from
the top, to avoid creating strokes
that are excessively intense.*

*Draw directly with the sharpened
tip of the pencil. Rather, always
keep it tilted.*

7

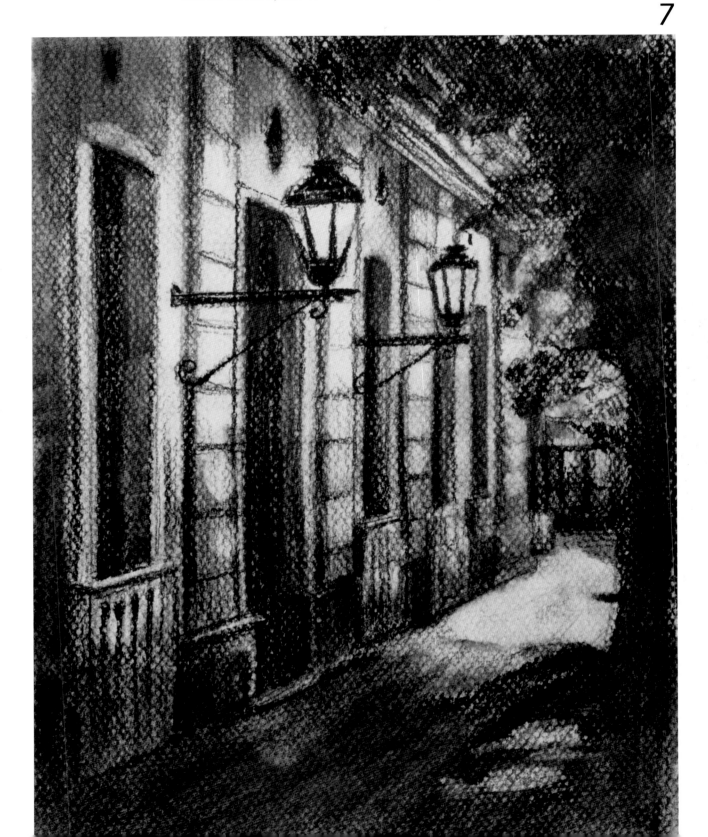

Here, we will go back to a very simple subject to produce the light and shadow effect with a technique combining three colors of chalk: ochre, white, and light and dark blue. The backlighting of an object on a windowsill will offer you the opportunity to practice this drawing technique, combining very different tones of chalk. In addition, this simple subject will allow us to introduce transparent objects—in this case, the thin, translucent curtain. Not only will you shade in this exercise, you'll also add light to the drawing, applying white chalk highlights where appropriate.

Shading with Various Colors of Chalk

1

2

Tip
To establish the initial values in the drawing, drag the chalk across the paper lengthwise to quickly shade large areas.

1 The drawing consists of linear strokes, drawn with the end of the stick of blue chalk. The layout is quite simple.

2 Shade around the window with the same chalk; then use the light blue chalk to darken the landscape in the background.

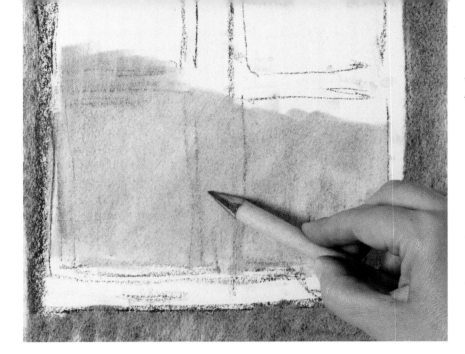

3

3 In this next step, you will blend the shading by strongly rubbing it with the smudge stick. Leave the paper blank in the light areas.

4 The tones now appear uniform and establish a good base to begin sculpting the shadows and developing the shading effects of light, shadow, and backlighting.

4

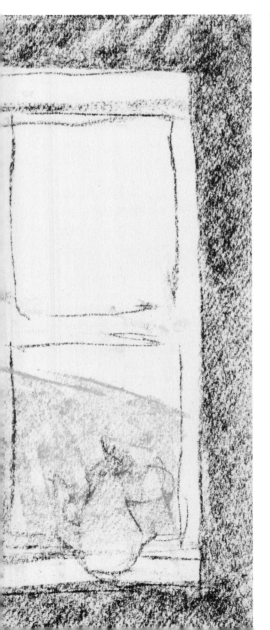

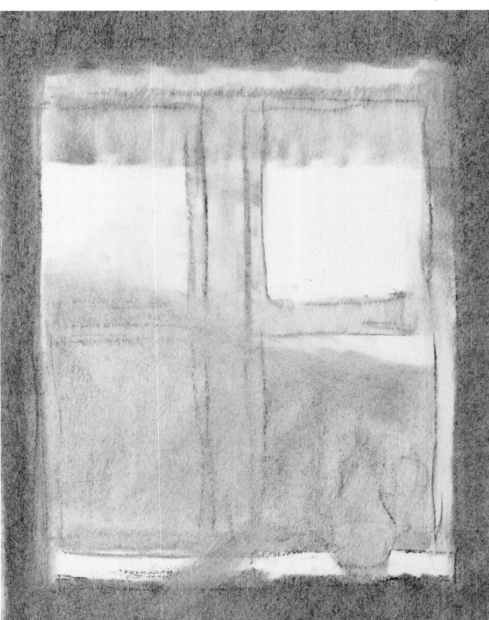

Two New Colors

Now is the time to add two new colors of chalk:
a yellow ochre chalk—which adds a nice, warm
counterpoint to the blue shaded base—and white
chalk, which you will use to add the highlights and to
give the curtain a transparent look.

5

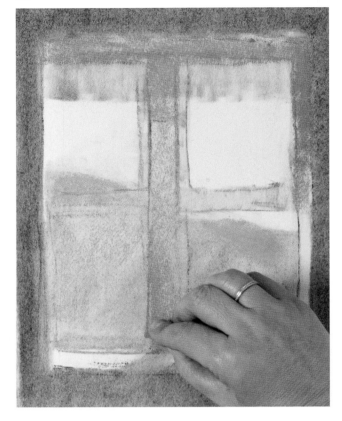

6

5 Fill in the window frame with a stroke of yellow ochre,
just a half-inch wide. The stroke should appear more
opaque on the upper part.

6 Use the sharp edge of the stick of blue chalk to draw
some fine lines on the window frame and the teakettle
resting on the windowsill.

7 Use the white chalk to strongly
establish the highlights on the
windowsill, and add a few
light strokes to suggest
the transparency of the
curtain.

8 Finish by adding
another round of blue
shading, but this time
without smudging.
This will highlight the
shadowed look of the
wall and the parts of the
frame darkened by the
backlighting.

DO ⬆

*Lightly apply spray fixative to the
drawing after each phase of shading,
to keep the colors from blending
together as you overlap them.*

DON'T ⬇

*Get too hung up on the details. The end
product should have a loose look.*

7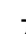

8

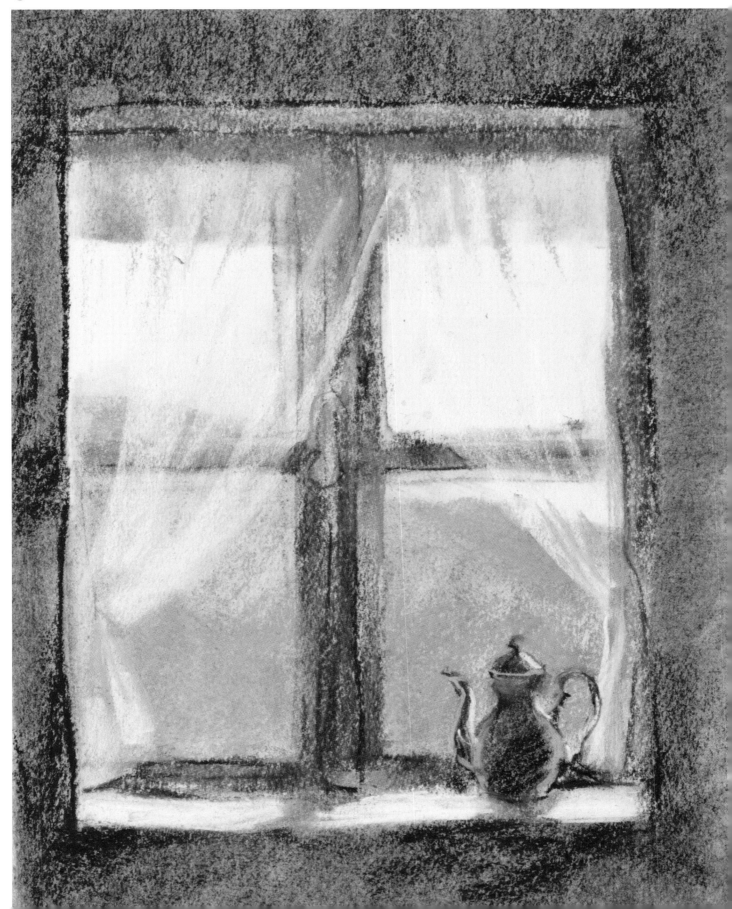

In the first part of this book, we talked about the sculpting technique and the importance of adequately describing the volume of the human body, especially when it comes to the contours of the skin. The following exercise involves drawing a pair of hands, describing in minute detail the areas of light and shadow, with gradated areas that you will sculpt with your fingertips to best describe the texture and form of the hands. You will be using two different tones of sanguine and applying a few final touches with brown chalk.

A

Hands in Light & Shadow with the Sculpting Technique

B

A Use a sanguine pencil to lay out the linear sketch of the hands, adequately defining their outline.

B Now use a stick of sanguine to lay out the main areas of shadow, properly contrasted, and blend them with your fingertips.

C The precision of your sanguine pencil will allow you to adjust tones, strengthening gradations and detailing the fingernails.

D When you have finished sculpting the skin's texture, use a brown chalk pencil to emphasize the darkest areas.

If your sculpting technique is delicate and you respect the highlights of the hand (touching them up with your eraser), the final shading effect of the skin's texture will be complete.

C

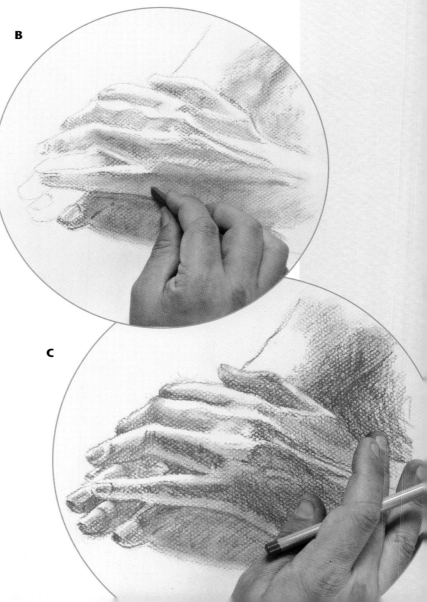

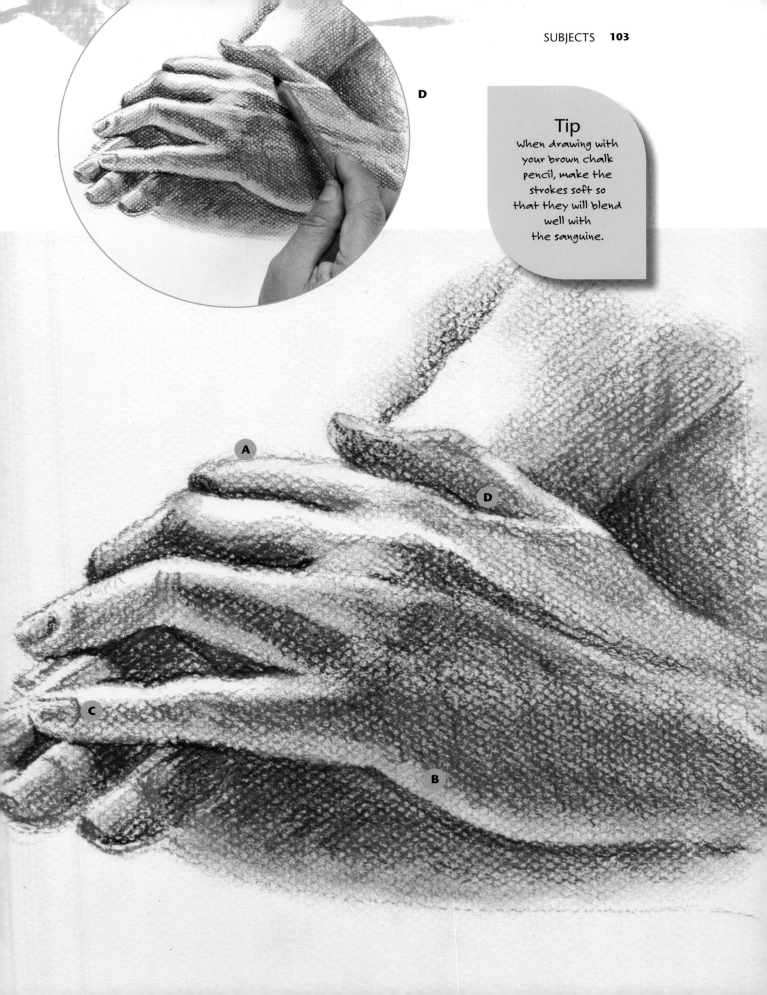

D

A

D

C

B

The key to creating an accurately shaded piece with colored pencil lies in learning how to overlap shading and hatching. The direction of your strokes is of fundamental importance here, to make sure that the drawing projects a proper sense of depth and three-dimensionality. Shading with colored pencil is done with soft transitions, progressively establishing values to create the strongest contrasts at the end by pressing down hard and saturating the paper with pigment. Let's get started.

Shading with Colored Pencil

1

2

1 The subject here is a very simple vase with a rose. Do the initial drawing with a graphite pencil, or if you prefer, you can begin working directly with your blue colored pencil.

2 When drawing with colored pencils, you must use very soft strokes, since it won't erase as easily as graphite. For this reason, you should try to avoid making too many mistakes.

3

3 The values on the flower's petals are quite light, and they contrast with the much darker shading in the background.

4 It's a good idea to create the flower and the background at the same time, because the dark background is what will actually establish the contours of the rose and show the light hitting it.

Tip
Use high-quality pencils, as they contain more pigment in their core.

4

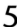

Simultaneous Contrast

Allow the contrast between your subject and its dark background to define it, rather than blur it. It is especially important to keep from silhouetting the form with unnecessary strokes and to make sure the volume inside it appears strong and decisive.

DO

Remember that the cast shadow is just a distortion of the subject's form.

DON'T

Oversaturate the paper with too many strokes. It's best for the paper's grain to be visible.

5

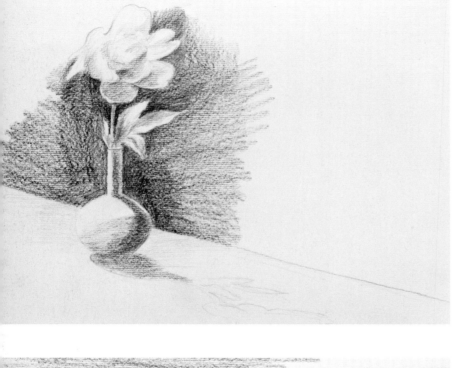

5 Establish the vase and the cast shadow with just two shades of blue. Complete the subject's form against a dark background, which plays a very important role here, as you strengthen it bit by bit.

6 As you cover the background with new strokes, it will become more and more apparent how important background shading is for establishing the solid form of the subject and defining the areas in light.

7 Use the sharpened tip of your pencil to work on the subject again, darkening its shadows and creating the fade effect that will define the shadow it casts.

6

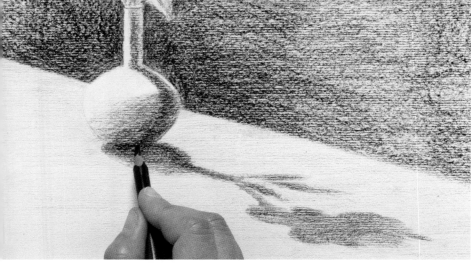

7

8 The last touches on the rose's petals will give a final light and shadow effect to your subject. The success of your drawing depends largely on how the background affects the volume of your subject.

8

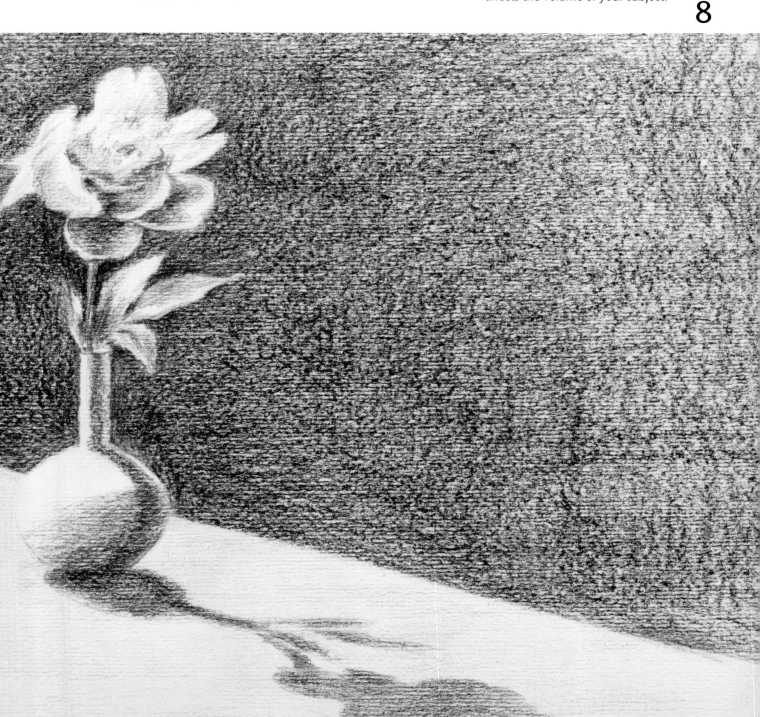

1

In the following exercise, you will again be depicting flowers with shading. You will use charcoal again here; this exercise, however, involves a significant use of your smudge stick as well, to delicately sculpt the flower's petals. The contours of the subject appear somewhat imprecise to give your composition a final atmospheric effect, similar to an out-of-focus photograph. Work on colored paper to soften the impact of the light.

Flowers with Blended Shading

1 Draw a loose sketch of the subject, with two more or less circular shapes, using very few strokes.

2 Use your flat charcoal stick to apply a first layer of shading to the background, which will help to better visualize your subject.

2

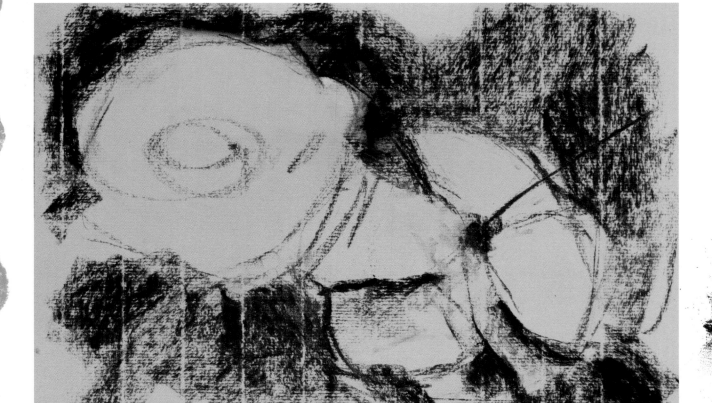

3

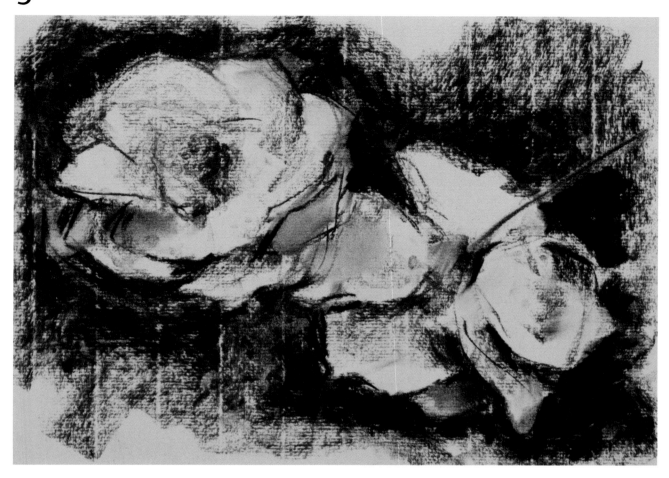

3 Use the tip of your charcoal stick to sketch the shape of the petals. Don't be afraid of making intense strokes, as charcoal does not adhere too permanently to the paper.

4 Start blending, working on each petal individually, blending the edges with the dark tones in the background.

The impermanence of charcoal, which falls from the paper's surface at the slightest touch, favors exercises in which the fading effect is especially relevant.

4

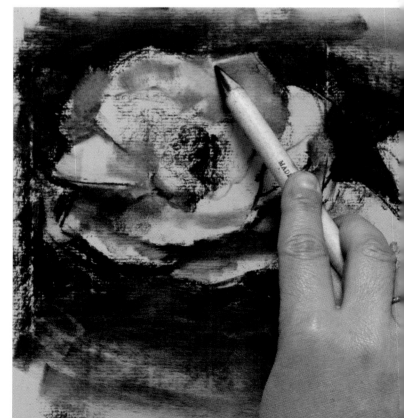

Blending with Light and Shadow

Smudging is a common technique when working with light and shadow, used to obtain atmospheric unity. Values blend together, and light and shadow alternate continuously and fluidly.

5 After smudging, the petals look like a faded, gray-colored patch with a silky texture, suggesting certain forms without fully describing them in detail.

6 You will need to erase some areas with your eraser in order to recover the areas in light and finish defining the shape of the flowers.

5

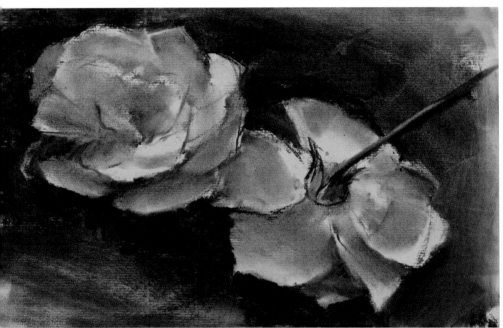

6

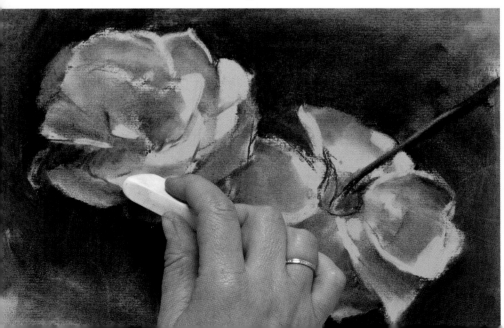

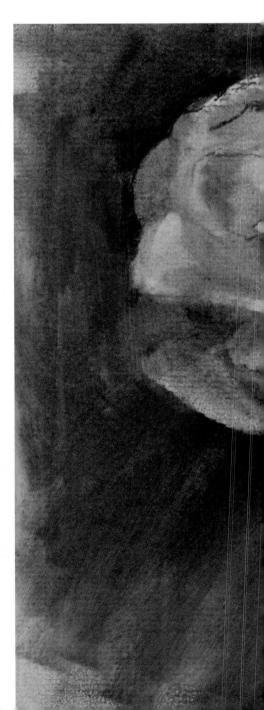

Charcoal is the best medium for working with a smudge stick. Your strokes will leave a large amount of loose charcoal on the paper's surface.

7 Finish by drawing a few strokes with the edge of your charcoal stick on top of the blended, smudged areas, which will suggest the stems and edges of the petals.

DO

Leave some areas of the background dark—in other words, don't smudge them all.

DON'T

Try to recover the shape of objects with lines that are too clear. Imprecision is the key here.

7

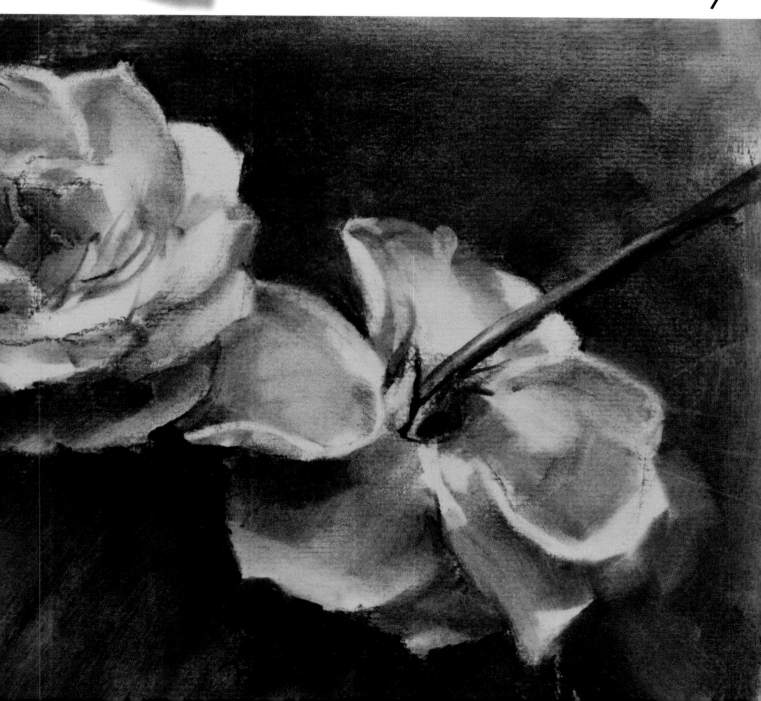

Drapery with Chalk

When drawing drapery, the most important thing is to properly establish its relationship with the light. The folds, curvatures, and undulations of the fabric should be significant, so that the shadows will be visible and the volume and shape of the folds will be emphasized. The lower the light is, the darker and more contrasting the values of the shadows will be, and the easier it will be to draw them. In this exercise, you will be drawing a cloth in an interesting, spiral presentation, using two shades of blue chalk.

The key to success lies in paying careful attention to the layout of the wrinkles and working your way up from less to more. In other words, start with the soft shadows, and finish by emphasizing the darker ones.

A Softly draw the most significant lines that establish the direction of the folds, which will orient the shading of the drawing.

B Begin with the lightest blue chalk on the lower parts of the folds, where the shadow opposite the fold brings out the shape and highlight of the fabric.

C Blend the shadows, fading the shading. The result will be a convincing depiction of the swells and depressions of the cloth.

D Intensify the shadows with a more intense blue chalk, emphasizing the most pronounced folds.

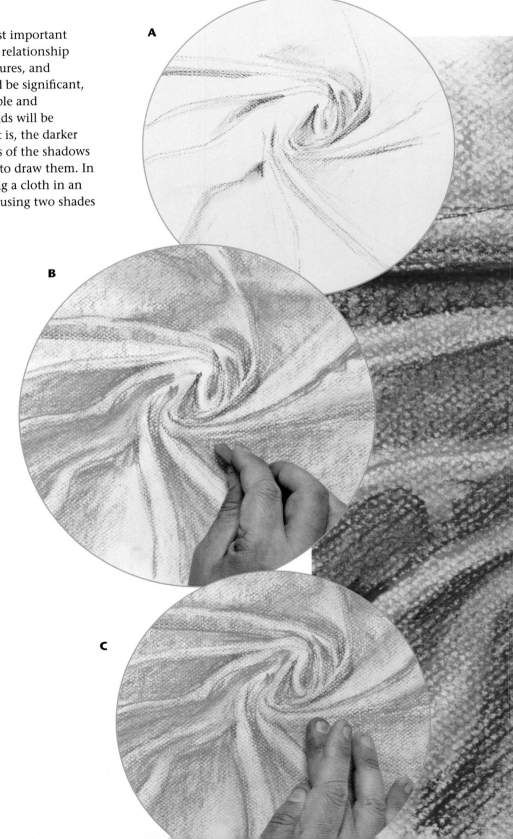

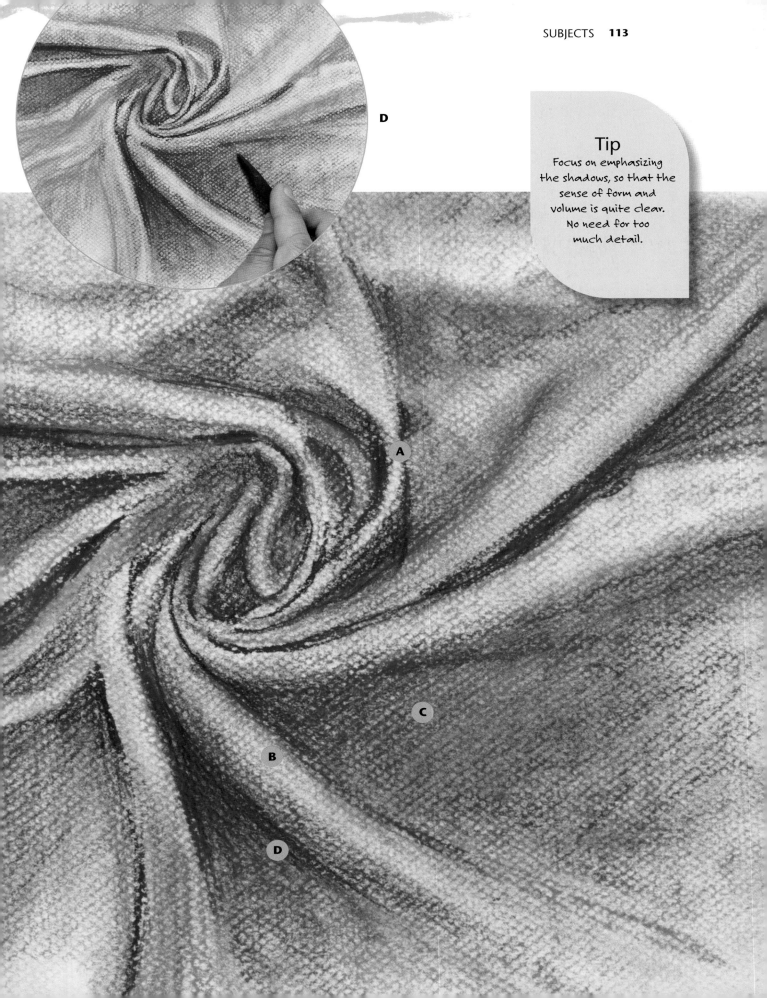

D

A

C

B

D

Flat Shading of a Human Figure

As is the case with other artistic genres—including still life and landscape—one of the most effective ways to begin using light and shadow when drawing the human figure is by using a flat, plain color with a dry technique. The best option here is the charcoal stick. In addition to its characteristic depth of tone, charcoal—by its very nature—will allow you to work broadly with shadows, without the need to be too meticulous.

A First, lay out the figure with the tip of your charcoal stick. Try to manage an approximate representation of the model's profile.

B When shading with the flat charcoal stick, the important thing is to maintain a continuous stroke, rotating the position of the stick depending on the thickness of the stroke you desire.

C The drawing is reinforced by shading the blocks of shadow that follow the contours of the figure's body, leaving the corresponding areas of light blank.

D Smudge the structural lines with your finger, allowing the drawing to be discerned by contrast, rather than specific outlines.

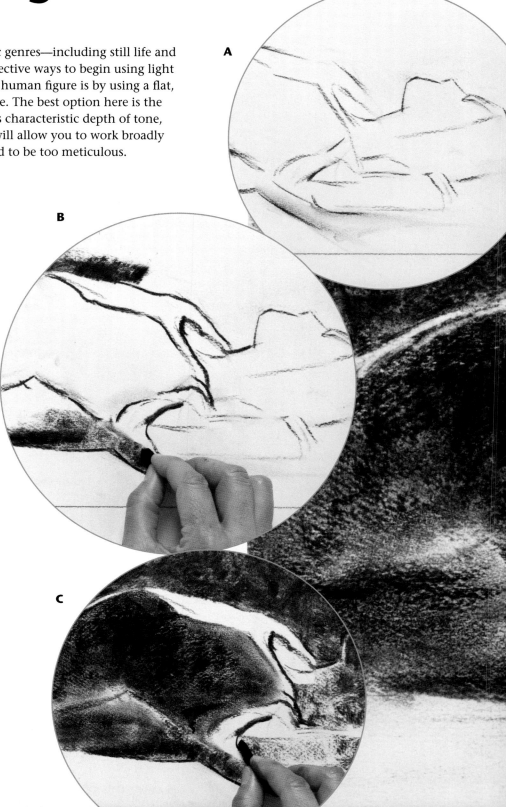

A

B

C

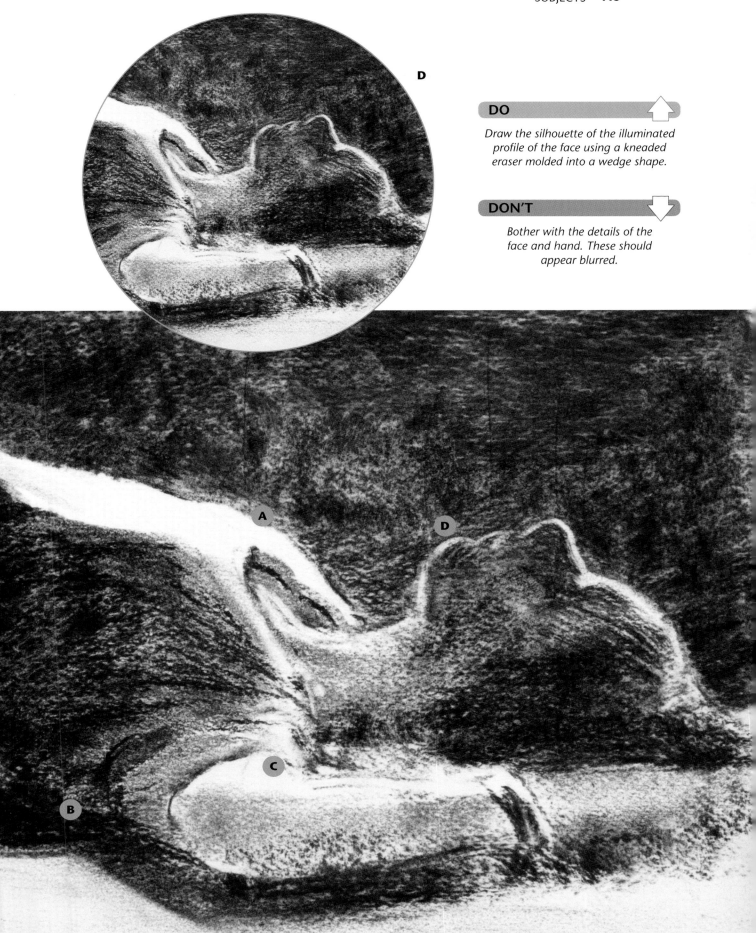

DO

Draw the silhouette of the illuminated profile of the face using a kneaded eraser molded into a wedge shape.

DON'T

Bother with the details of the face and hand. These should appear blurred.

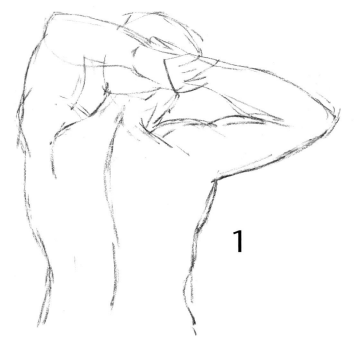

1

When drawing a nude subject's back with a shading effect, it is important to remember that the light does not illuminate the subject entirely. On areas in direct light, leave some parts blank, allowing the white of the page to show through. This will submerge the rest of the figure in intense shadow. The shadow should be highly blended and faded to properly describe the texture of the figure's anatomy. In this drawing, use a combination of charcoal and sanguine pencils, a smudger to blend the shadows, and white chalk along with a kneaded eraser to create the highlights.

Nude Figure in Light & Shadow

2

1 Create the initial drawing with quick strokes that clearly establish the outline of the male figure, as well as the main elements of his anatomy: the crease in his shoulder and the indent of his spine.

2 The first layer of shading consists of drawing soft, parallel strokes with your charcoal pencil. To keep from producing tones that are excessively heavy, don't press down too hard with the pencil.

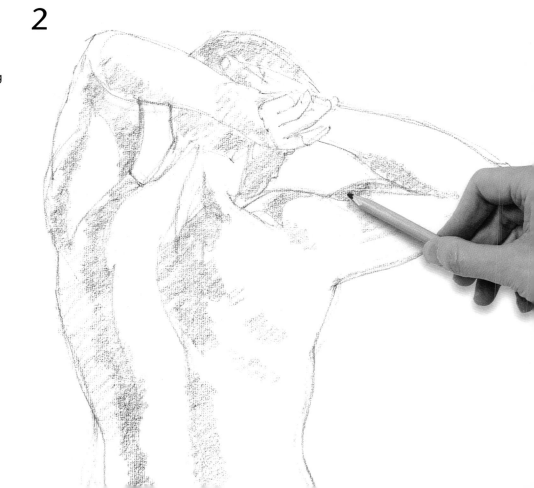

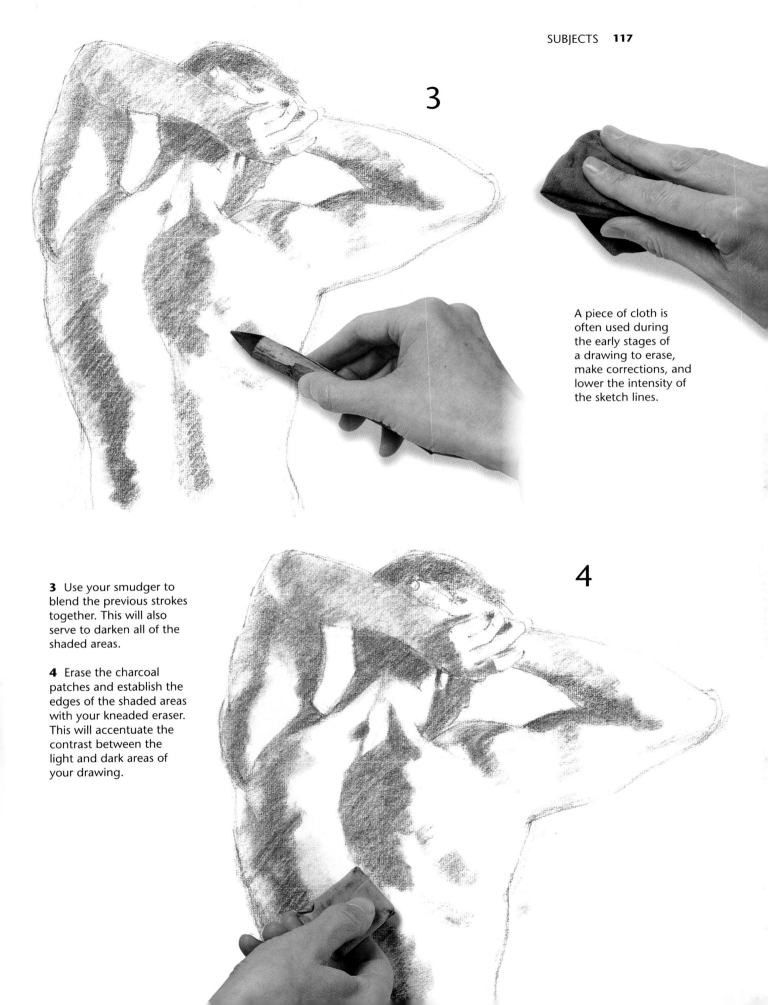

3

A piece of cloth is often used during the early stages of a drawing to erase, make corrections, and lower the intensity of the sketch lines.

4

3 Use your smudger to blend the previous strokes together. This will also serve to darken all of the shaded areas.

4 Erase the charcoal patches and establish the edges of the shaded areas with your kneaded eraser. This will accentuate the contrast between the light and dark areas of your drawing.

A Greater Variety of Values

Now it's time to add a wider variety of values to complete the initial shading of the drawing. Use sanguine for this, as it will allow you to create more intermediate tones. Charcoal strokes, by contrast, will simply darken the values of your drawing. This will define the outline of the figure's shadows and give your composition a greater variety of tones, which will better describe the volume of the figure's body.

5 Your drawing now has a unified tonal look. At this point, you will begin to reinforce and develop the details, incorporating soft parallel strokes with your charcoal pencil, which will establish a greater sense of depth and relief within the anatomical details.

5

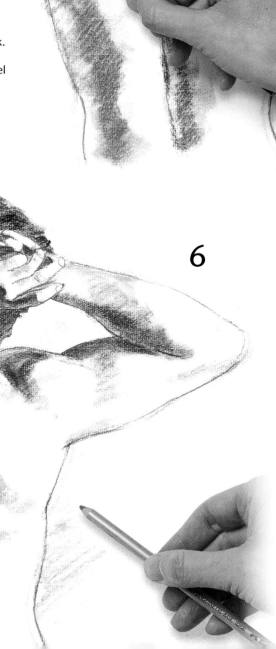

6

6 The texture of the figure's back is now almost fully developed. Shade the paper with sanguine pencil strokes to emphasize the light areas of the subject.

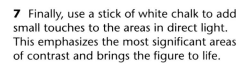

7 Finally, use a stick of white chalk to add small touches to the areas in direct light. This emphasizes the most significant areas of contrast and brings the figure to life.

8 In the final drawing, you can see how well the details stand out, thanks to the effective use of shading.

7

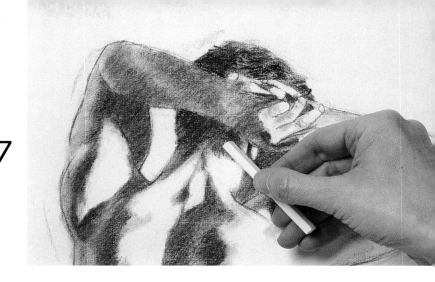

DO	DON'T
Develop a solid initial drawing, especially when your model is a human figure.	*Make the shadows on the figure overly compact, as this won't allow the grain of the paper to breathe.*

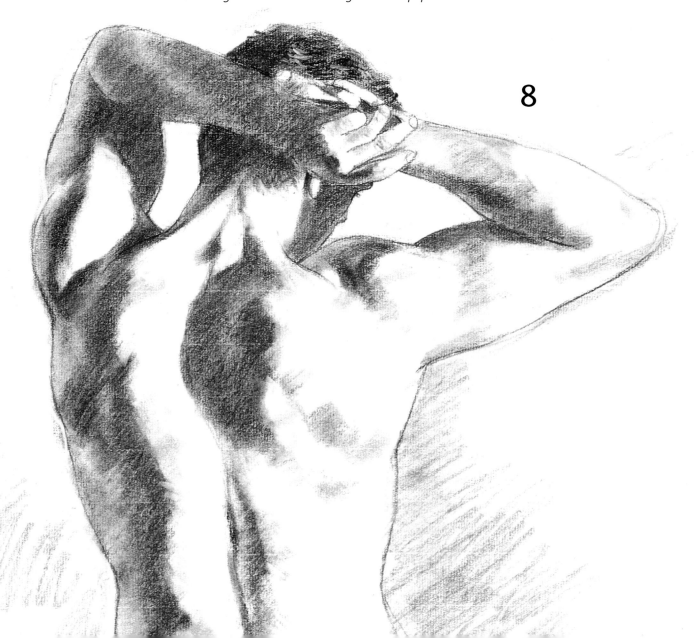

8

Face in Dark-Toned Shading

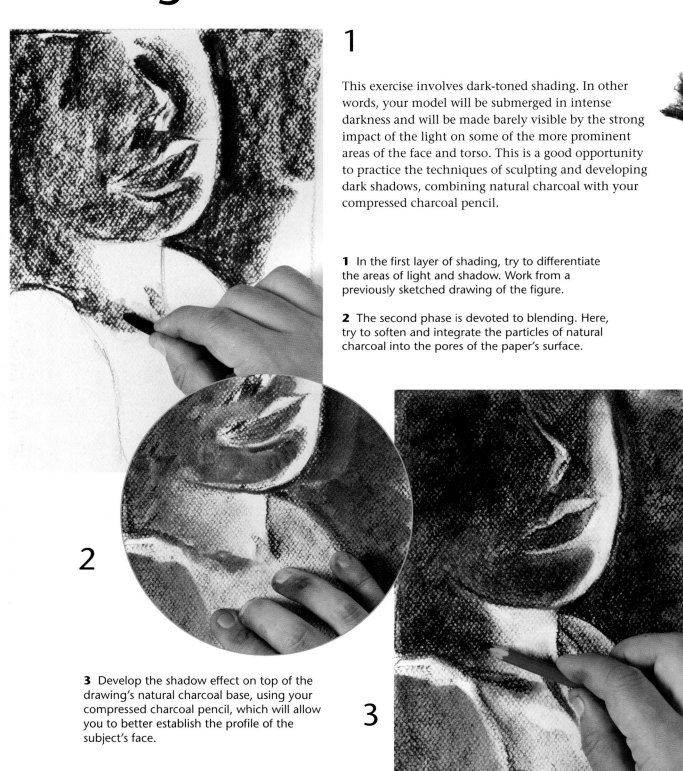

1

This exercise involves dark-toned shading. In other words, your model will be submerged in intense darkness and will be made barely visible by the strong impact of the light on some of the more prominent areas of the face and torso. This is a good opportunity to practice the techniques of sculpting and developing dark shadows, combining natural charcoal with your compressed charcoal pencil.

1 In the first layer of shading, try to differentiate the areas of light and shadow. Work from a previously sketched drawing of the figure.

2 The second phase is devoted to blending. Here, try to soften and integrate the particles of natural charcoal into the pores of the paper's surface.

2

3 Develop the shadow effect on top of the drawing's natural charcoal base, using your compressed charcoal pencil, which will allow you to better establish the profile of the subject's face.

3

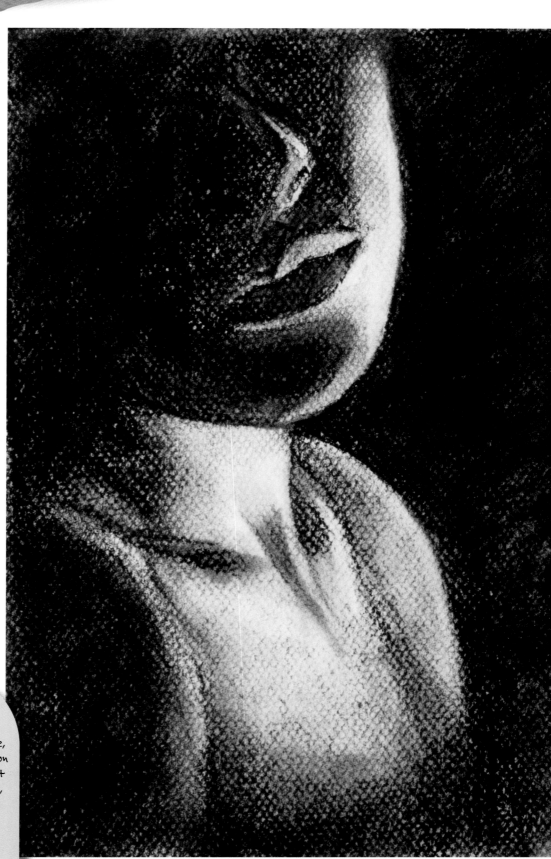

Shading with natural charcoal is not just a way of representing your subject—it implies character and decision. Many artists choose natural charcoal for shading.

4

4 The blackness of the compressed charcoal will allow you to finalize the deep black areas that surround the starkly contrasting lit areas. Some contours of the figure will appear pronounced, while others will blend in with the black gradated areas.

Tip
Sculpt the outline of the shadows with care, taking into consideration the shape of each part of the torso and face, so that the shadow is properly rounded and contoured.

Urban Subject with Ink Wash

We couldn't finish this book about shading techniques without working with ink and ink wash. This step-by-step project will test your ability to draw with a brush, adding colored wash for the shading effect. To successfully complete it, you will need to pay careful attention to how you use your brush as a drawing tool, and you will be adding elements of wash—some of them more or less plain, others faded with just one color. The lighter tones will be heavily diluted in water, while the darker ones will have barely any water. Before you begin to paint, it's a good idea to review the chapters that deal with ink wash again (pages 15 and 62).

1 First make a simple pencil drawing of the hydrant. You don't need to include minute details, but your sketch should be approximately accurate.

2 Use a white-colored oil pencil to set aside the blank areas that you don't want to be covered with the ink wash.

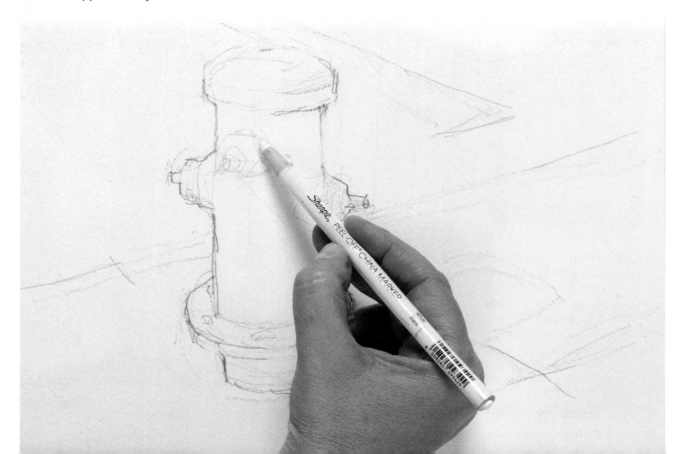

3

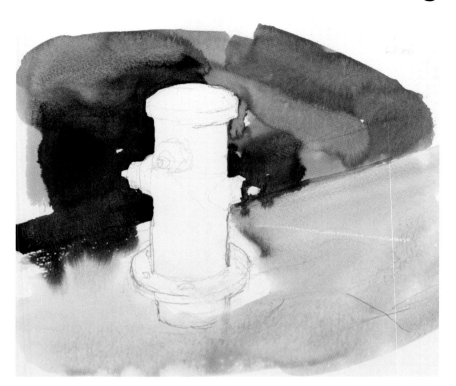

3 Prepare an initial, very diluted ink wash and brush it across the pavement in the drawing. Before it's dried, apply a second, more intense wash to the asphalt of the street.

4 Extend the shadow of the hydrant, making sure to leave the area in direct light blank. Washes are not uniform in nature, and will show small nuances and variations of tone.

Tip
Work simply, with clean washes. Don't worry about touching up details.

4

Applications on a Wet Surface

You will apply the new additions of tone to the still wet wash, since the water on the paper will transport the color. This will create irregular splotches and eroded areas that will break up the uniform look of the shading.

The tone of your wash depends entirely on the amount of water you add to the ink.

5 Add a bit more color while the wash is still wet. This will allow the new value of the ink to blend with the gray already on the paper, creating gradations.

5

6

6 Use a sharp nib pen to add a few linear strokes with dense, undiluted ink. Wait for the wash to completely dry before doing this.

7 All that's left to do is to define the cast shadow with a medium shade of gray. To do this, make wet applications of intense India ink to the base of the hydrant, producing a light shadow.

DO

Have a white wax pencil handy to set aside blank white areas. It is water-resistant, and will preserve the shine and reflections of its color.

DON'T

Manipulate a wash when it's wet to lighten it. The gray tone will become less intense when it dries.

7

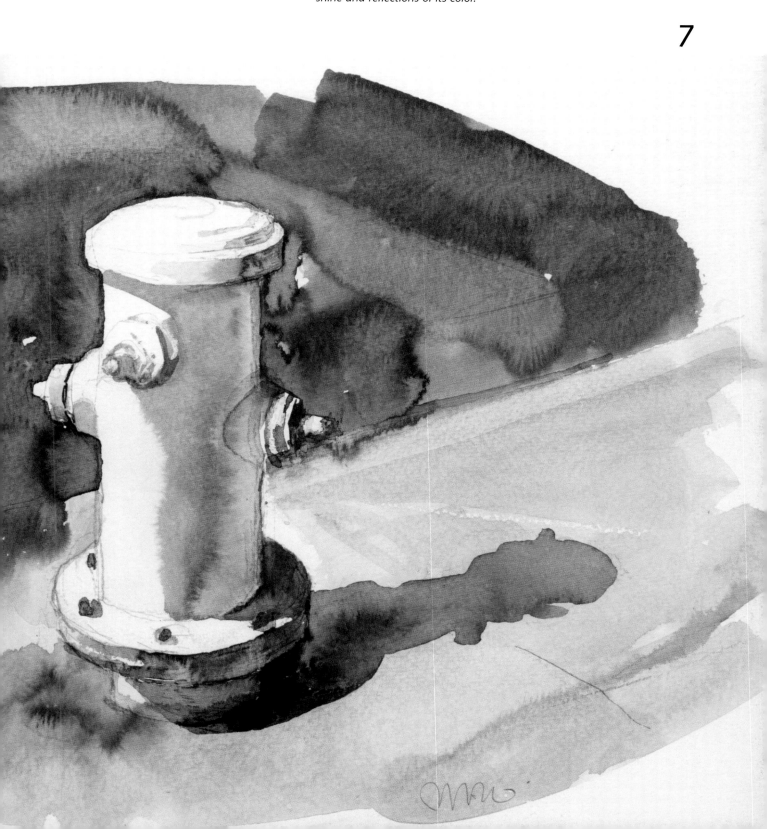

Portrait of Girl with Ink Hatching

1

In this last exercise, you will be using a reed pen as your drawing tool. This involves creating ink hatching in order to represent the subject's face in light and shadow. The combination of hatching—with strokes of varying intensity and thickness—will give you a remarkable end result. The final image will be characterized by a rich tonal value scale, which will suggest the features of the subject's face, the texture of her hair, and the quality of the shadows quite well.

1 It is important to define your drawing before you begin to apply the washes. It is also of fundamental importance to make extremely clean pencil strokes.

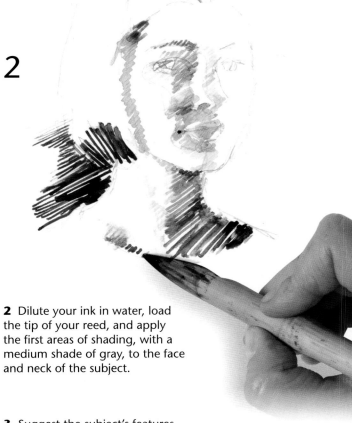

2

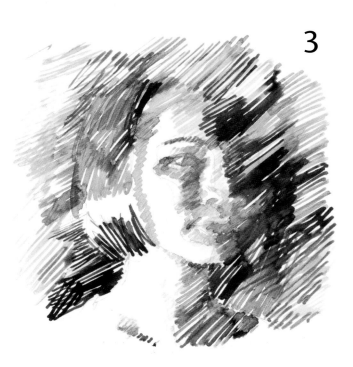

3

2 Dilute your ink in water, load the tip of your reed, and apply the first areas of shading, with a medium shade of gray, to the face and neck of the subject.

3 Suggest the subject's features with very light strokes. To emphasize the outline, on the other hand, you will be using more intense strokes. Do not draw any strokes on the highlighted areas of the drawing.

DO ⬆

Vary the direction of the strokes in the hatching, depending on the area of the head you are shading.

DON'T ⬇

Draw a new area of hatching on top of a previous one that hasn't completely dried yet.

4 Using medium tones, create a base of shadow that you will solidify and intensify by adding intense black strokes, using undiluted ink.

4

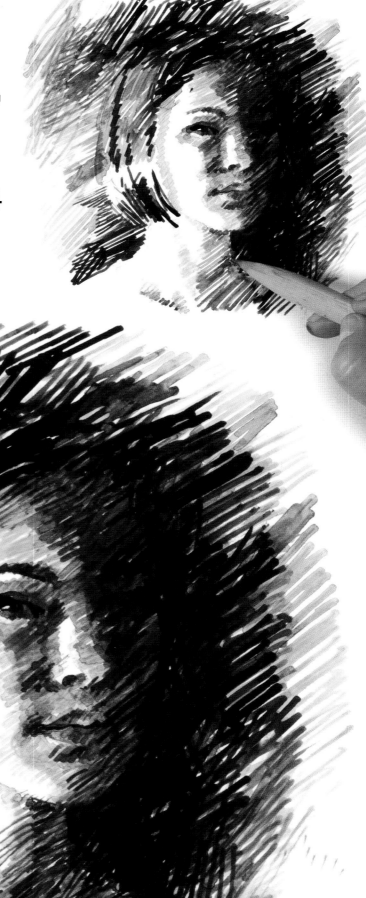

5 In the finished piece, the light and shadow effect obtained with the hatching is remarkable. The illuminated half of the subject's face emerges from a dark background, created through a series of overlapping diagonal hatching patterns.

5

Drawing for the Beginning Artist

Dibujo en Claroscuro
© 2016 Parramón Paidotribo—World Rights
Published by Parramón Paidotribo, S.L.
Badalona, Spain

Quarto is the authority on a wide range of topics.
Quarto educates, entertains, and enriches the lives of our readers—
enthusiasts and lovers of hands-on living.
www.quartoknows.com

Project design and creation:
Parramón Paidotribo

Editorial Manager:
María Fernanda Canal

Editing:
Mª Carmen Ramos

Text:
Gabriel Martín

Drawings:
Gabriel Martín
Merche Gaspar
Mireia Cifuentes

Design:
Josep Guasch

Text and page layout:
Estudi Guasch, S.L.

Photographs:
Nos & Soto

Production:
Sagrafic, S.L.

Translation:
David J. Schmidt

6 Orchard Road, Suite 100
Lake Forest, CA 92630
quartoknows.com
Visit our blogs at quartoknows.com

Printed in Spain
3 5 7 9 10 8 6 4 2 1